THE NORTH AMERICAN INDIAN PORTFOLIOS

FROM THE
LIBRARY OF CONGRESS

THE NORTH AMERICAN INDIAN PORTFOLIOS

FROM THE LIBRARY OF CONGRESS

BODMER • CATLIN • MCKENNEY & HALL

ABBEVILLE PRESS • PUBLISHERS

NEW YORK • LONDON • PARIS

First edition Tiny Folios™ format, second printing.

Library of Congress Cataloging-in-Publication Data

The North American Indian portfolios from the Library of
Congress :
 Bodmer—Catlin—McKenney & Hall / [selected by James
 Gilreath].
 p. cm.
 Includes index.
 ISBN 1-55859-601-1
 1. Indians of North America—West (U.S.)—Pictorial works. 2.
Indians of North America—West (U.S.)—Portraits. 3. West (U.S.)
in art. 4. Art, American. 5. Art, Modern—19th century—United
States. I. Gilreath, James, 1947– . II. Library of Congress. Rare
Book and Special Collections Division.
 N8217.I5N67 1993
 769'.4997800497—dc20 93-24603

CONTENTS

INTRODUCTION

For centuries the Plains Indians lived undisturbed and relatively isolated in the central part of what now is the United States. The various tribes, which included the Arapaho, Cheyenne, Sioux, Comanche, Kiowa, among others, were, with the exception of the Mandan, nomadic. Each followed the herds of buffalo that roamed the plains, only occasionally coming into contact with white trappers who traded pelts and other skins. The tribes' relative isolation rapidly changed after the Lewis and Clark expedition in 1804 sparked official United States government interest in the West. The country quickly began to realize the vast promise and resources of the West. As the West lured more and more interest from the government and private sources, interest in the American Indians grew

apace. American settlers inexorably moved westward to find cheaper land, land the Indians thought belonged to them.

The range of attitudes about the Indians in the new republic reflected the intensity of the curiosity about them. At one end of the continuum, they were vicious savages who stood in the line of progress; at the other, they were noble savages, a pure people unaffected by corrupt civilization, an idea that traced its intellectual lineage deep into Western civilization's past. A people who had been self-sufficient and insulated from the white world came, in the nineteenth century, to find the world peering at them, and at times even using Indian cultures as laboratories to test social theories about the nature of natural man.

Artists trekked to the West to paint images for those unable to make the journey. An outstanding collection of these travel accounts and illustrated books is part of the Library of Congress's rich collection of Americana housed in the Rare Book and Special Collections Division. Fulfilling one of the Library's central missions—to document the printed, visual, and written history of this

country—the images in this book constitute part of the archive of the American memory. The most significant printed images of the Plains Indians before the Civil War are those from the three books in this volume—Thomas L. McKenney and James Hall's *History of the Indian Tribes of North America* (Philadelphia, 1835–36), George Catlin's *North American Indian Portfolio* (London, 1836), and Prince Maximilian Alexander Philipp von Wied-Neuwied's *Reise in das innere Nord-America in den Jahren 1832 bis 1834* [*Travels in the Interior of North America between 1832 and 1834*] (Koblenz, 1839–41). Each of these three almost exactly contemporaneous books represents a radically different aspect of how Americans perceived the American Indian. These volumes are some of the most important sociological, historical, and ethnological studies of American Indians that also tell us much about the prevailing white attitudes toward the Indians. The differences among the three are readily apparent at a glance, in the style of illustration.

McKenney and Hall's *History of the Indian Tribes of North America* consists almost entirely of portraits—stiff

and wooden—in which the subjects show little expression. The value of their work was in preserving likenesses of some of the most important Indians of their time. They revealed the novelty of the Indians to eyes more accustomed to European culture, conveying the idea that here is a people who do not look like us and whose geographical remoteness makes it unlikely that the viewer will have the opportunity to see them at first hand. They are exotic, unknowable, and perhaps a little frightening. At the very least they are curious, and a viewer might look at them as he would look at a book of illustrations of unusual plants or animals, which were also common at the time. In fact, the views of the Indians in McKenney and Hall's book are similar to ethnological studies, displaying only the surface of Indian culture. The coloring on each Indian differs, but the poses are almost exactly the same, and no personality is shown. They are less individuals than parts of a species to be observed.

Strikingly different from McKenney and Hall's work is *Reise in das innere Nord-America in den Jahren 1832 bis 1834*. Whereas *History of the Indian Tribes of North*

America consists entirely of still portraits of Indians, *Reise in das innere Nord-America in den Jahren 1832 bis 1834* contains images of Indians performing ritual dances, such as the Buffalo Dance, as well as views of the landscapes familiar to the Plains tribes. Prince Maximilian brought with him a young Swiss artist, Karl Bodmer, on his trip up the Yellowstone River. Bodmer painted as the Maximilian party traversed the two-thousand-mile stretch from St. Louis, the unofficial entry to the West at this time, to Fort Union, at the confluence of the Yellowstone and Missouri rivers, near the present-day North Dakota–Idaho border, and beyond. Later, the artist's work was copied by the aquatint process, and published as a book, containing prints in two sizes, forty-three large ones, called Tableaux, and thirty-eight small illustrations, termed Vignettes. The vignettes begin with a view of Boston harbor (Vignette 1), move to Delaware, through Pennsylvania, including Bethlehem (Vignette 3), and then onto the Ohio and Mississippi rivers. The vignettes are more heavily weighted to the Eastern part of the journey. The larger tableaux, however, tend to tell

a little more about the Western part of the journey, presumably because the larger format was more suitable for the wider and less familiar western expanses. After opening with a view of the Lehigh River (Tableau 1), the tableaux jump to New Harmony (Tableau 2), the experimental socialist community in Indiana founded by Robert Owen. Though Maximilian and his party would have had to travel through St. Louis, Maximilian chose not to illustrate this part of the journey but turned instead to the American Fur Company steamer *Yellowstone*, which took passengers from St. Louis as far up the Missouri as it would navigate, at which point they would have to embark in smaller boats. A greater number of the tableaux focus on the extreme western part of the journey, depicting the customs of the Mandan, as well as the trading posts, Fort Union and Fort Pierre.

The illustrations in *Reise in das innere Nord-America in den Jahren 1832 bis 1834* carry the reader along from page to page with their beauty. Not only are the landscapes of the West haunting and breathtaking, but the colors Bodmer used are alternately subtle and vivid. The

country along the Yellowstone is depicted as romantic, wild, and untamed. It appears to be vast in its nature and dramatic in its abrupt changes (Tableau 37). The limbs sticking up from the water (Tableau 6) and the wild birds brooding over its extent (Tableau 15) hint at the danger and were meant to thrill the armchair traveler. The country's great beauty and dimension swept the viewer farther westward, offering unlimited potential.

Despite the differences between *History of the Indian Tribes of North America* and *Reise in das innere Nord-America in den Jahren 1832 bis 1834*, there is one subtle similarity between the two books. There is no question that the illustrations in both books provide posterity with irreplaceable contributions to knowledge about costume, weaponry, body decoration, and other matters related to the Indians. Still, we sometimes get the disquieting feeling that both books ignore the reality of Indian character and culture, Maximilian's by imposing a classically correct style and McKenney and Hall's by limiting itself to a scientific stiffness without probing below the surface of its subjects. Perhaps this similarity is why Maximilian

approved of the proofs of McKenney and Hall's book when he saw them in Philadelphia. With its objective and dispassionate ethnological attitude, McKenney and Hall's work imprisons Native American culture in the same way that Bodmer's illustrations impose a perfect but artificial style. For example, Bodmer's arrangement of groups of Indians, as in the "Bison Dance of the Mandan Indians" (Tableau 18), can be traced to European classical paintings. The perfect balance in some of the frames chosen for the book is too correct for real life, and dissipates some of the pictures' energy, leaving us feeling that what we are looking at has been posed and fitted into a European tradition of classical painting rather than having been based on an actual observation of what took place along the Yellowstone River.

The third book, George Catlin's *North American Indian Portfolio*, differs from the other two in fundamental ways. Its illustrations are inferior in style and design. Astonishingly, the lithographer who copied Catlin's original drawings improved them. Catlin had difficulty with proportion, and his work often shows a lack of depth and

attention to detail. Compared to the rich complexity of Bodmer's work, as shown in *Reise in das innere Nord-America in den Jahren 1832 bis 1834*, Catlin's pictures appear almost childlike in their simple execution and lay-out. The lush patterns and apparent depth of Bodmer's depiction of "Pehriska-Ruhpa" (Tableau 18) contrasts sharply with the flat stiffness of Catlin's "Joc-O-Sot."

Yet despite the lesser artistic merits of the *North American Indian Portfolio*, it possesses certain qualities that exceed the other two books reproduced here. Catlin's work endeavors to tell the story of the Plains Indians in a logical, graphic way that is not evident in Bodmer's or McKenney and Hall's works. Catlin introduces the viewer to three important tribes from different geographical areas (Pawnee, Osage, and Iroquois) in the first image; the second illustration presents the buffalo, the animal on which the Plains Indians depended for survival. Not only did the Plains Indians hunt the buffalo for food, but they also used its hides for clothing and lodging and its bones for weapons and eating utensils. Next, Catlin depicts the wild ponies on the Plains, how the Indians broke them,

and finally how the Indians used the ponies to pursue the buffalo. The two main methods of killing the buffalo, with a lance and with a bow, are demonstrated in the subsequent print. The danger of the buffalo hunt follows, with the Mandan buffalo dance coming after. During the dance, the Mandan Indians would move in a circle, wearing a buffalo robe and sometimes a head. They would continue to move in a circle until they were exhausted, at which point others would take their places. The circling continued until a buffalo herd was spotted by one of the Mandan who were posted to keep an eye on the nearby areas.

The effort to tell a story about Plains Indian culture continued throughout the *North American Indian Portfolio*. Catlin tried to present Indian culture and activities from the Indian standpoint. Catlin's storytelling stands in contrast to McKenney and Hall's work, which has no narrative scheme. Also differing from Bodmer, Catlin took a thematic approach by depicting the elements of Indian culture that the Indians themselves viewed as important, whereas Bodmer arranged his illustrations as a straightforward chronology of a trip into the

American West between 1832 and 1834 from Maximilian's eyes. In fact, in the atlas of Bodmer illustrations the itinerary of the trip is offered twice.

Despite the fundamental differences between Catlin and Bodmer, both traveled from St. Louis up the Missouri on the *Yellowstone* to Fort Union at the intersection of the Yellowstone and Missouri rivers. They went within a year of each other, Catlin leaving in the spring of 1832, and Bodmer traveling with Maximilian—after wintering at New Harmony, Indiana, in 1832—heading west in 1833. Maximilian and his party journeyed another five hundred miles past Ft. Union, which was Catlin's furthest point west. Catlin and Bodmer painted similar scenes, such as the Mandan buffalo dance, and many of the same tribes. The paths they both took into the far West followed a series of trading posts that served as a conduit for the furs and pelts brought down from the Rocky Mountains and channeled east.

The story of the compilation of McKenney and Hall's *History of the Indian Tribes of North America* differs from that of Catlin's or Bodmer's books. Thomas McKenney

became Superintendent of Indian Trade in 1816, a position established to promote peace and regulate trade between the two races. At this time, each tribe was recognized as an independent sovereign power by the United States government, and separate treaties were enacted between each tribe and the federal government. One of McKenney's responsibilities was to purchase goods from private merchants and send them to the frontier trading posts where the wares were bartered with the Indians. His position was to last for only six more years, as private trading companies undermined the government's interests by using liquor and other such material for barter.

McKenney became concerned for the survival of the Western tribes, as he observed unscrupulous individuals taking advantage of the Indians for profit. His vocal warnings about the future of the Indian people prompted President Monroe to appoint him to the Office of Indian Affairs, which was charged with improving the administration of Indian programs throughout the government. Aside from his Washington duties, McKenney also tried to help the few students of Indian culture at this time, and

also traveled west to negotiate treaties with various tribes. His first trip was during the summer of 1826 to the Lake Superior area for a treaty with the Chippewa, opening mineral rights on their land. He joined the artist J. O. Lewis in witnessing the treaty, and the next year they collaborated on *Sketches of a Tour to the Lakes, of the Character and Customs of the Chippeway Indians, and of Incidents Connected with the Treaty of Fond du Lac*, with Lewis providing the illustrations.

McKenney journeyed west once again in 1827 for a treaty with the Chippewa, Menominee, and Winnebago in the present state of Michigan. During this journey he gathered information about the land and the various tribes in the area, an unparalleled opportunity to become acquainted with the Native American tribes in the Great Lakes area. It may have been at this time that he conceived publishing an ambitious illustrated work. When President Jackson dismissed him from his government post in 1830, McKenney was able to turn more of his attention to his publishing project. Within a few years he was joined by James Hall, who had settled into a law prac-

tice in frontier Illinois and had written extensively about the West. The two tried to enlist the cooperation of George Catlin, who was displaying his paintings and Indian objects in Eastern cities, but Catlin decided to strike out on his own.

As McKenney envisioned it, his work would be based primarily on the portraits of Indians hung in the Indian Gallery in the War Department in Washington, D.C. From the early 1820s, the secretary of war had engaged Charles Bird King to paint the portraits of Indians whose tribes had sent them to Washington on official business relating to the treaties. King also copied some of the portraits made by J. O. Lewis not only on his trips with McKenney to the West but also on Lewis's extensive solo travels. Though other painters contributed to the Indian Gallery, King's work, both from actual observation and from copying Lewis's, served as a major portion of the War Department collection. Lewis issued his own illustrated book, *Aboriginal Port-Folio*, though it is much inferior to the three depicted in this volume.

In 1836, McKenney and Hall began issuing their great

work, based primarily on the King pictures. The book was published over the next two years in a series of folio parts measuring more than 52 centimeters (20½ inches) tall and was later issued again both in the folio format and in a smaller octavo version, attesting to the book's popularity. The folio editions were illustrated with hand-colored engravings. The engravers charged with copying a picture in the Indian Gallery would engrave an outline of the painting on a large, smooth piece of copper. When ink was applied to the surface of the copperplate, some would sink into these lines drawn on the piece of metal, and the rest would be wiped clean. A sheet of paper pressed against the copperplate would pick up ink from the lines cut into the surface, and an image of the outline would be transferred to the paper. Artists would then be employed to paint the colors on each illustration before all the illustrations could be bound together. Posterity is fortunate that McKenney and Hall undertook this endeavor, because almost all the King paintings were destroyed in a disastrous fire after the collection had been transferred to the Smithsonian from the Interior Department, which had received them from the War Department.

If McKenney's interest in Native Americans was stimulated by his experience as a government official, George Catlin arrived at what he considered his great mission in life solely on his own. Catlin was an indifferent portrait painter of Eastern society before some Indians visiting in the East piqued his interest, which quickly became an enthusiasm, if not a crusade. He set out to become the visual historian of the Indian tribes and took several long trips west, sometimes leaving his family behind for months at a stretch. After he finished his western expeditions, he exhibited his paintings and Indian artifacts— teepees, pipes, clothing, and other such objects—in a number of American cities. He charged admission to these exhibits, a practice that led many to accuse him of being more interested in profit than in Indian culture. When Congress failed to heed his urging that the government buy the collection for public display, he moved the entire operation to England where he exhibited at Egyptian Hall, again for an admission fee. During his stay in England, he conceived the idea for the *Portfolio of the North American Indian*.

Before the age of photography, there was a rage in Great Britain and in Europe for large illustrated books depicting not only exotic natural scenes and objects, such as wild orchids in the Himalayas or South American parrots, but also subjects closer to home, such as English country houses. Catlin was clearly playing on this craze in *North American Indian Portfolio*. The two principle methods of illustrating these books were the hand-colored engraving, which has been explained above, and the hand-colored lithograph, which was the method Catlin chose. He selected some of his paintings and engaged a lithographer to copy them. The lithographer would take a smooth, polished slab of a special lithographic limestone and draw the outline of the image before him on the limestone with a greasy crayon. The surface of the limestone was then inked and washed. The ink adhered to the greasy outline drawn by the lithographer but washed away on the rest of the surface. When paper was pressed against the limestone, the outline image of the painting would be transferred to the sheet. As in the process of hand-colored lithographs, colorists would then apply the color to the outline for every

image. The lithographic process allowed a freer hand and was less time-consuming than engraving, though sacrificing the fine detail of the latter.

Catlin relied on his Indian exhibition and book to support him, but Maximilian needed no such support. He was born in 1792 to an affluent German family with an ancestral castle on the Rhine River near Koblenz. He was educated in the classics and studied with some of the finest minds in Germany. Through this education, he developed a lifelong passion for natural history, which included the history of the human species. A then current theory postulated that the human species was at different stages of evolution at different places on the globe, for environmental and ecological reasons. Thomas Jefferson, for instance, wrote his *Natural History of Virginia* to refute the French savant Count Buffon's contention that all species in North America were inferior and smaller to European species because of the American climate. Jefferson went so far as to have an American moose stuffed and sent to the Count in order that the animal's massive size would serve as a rebuttal to the unsubstantiated theory. Prince

Maximilian's trip to America aimed to study the natural history of the American landscape and to observe that stage of evolution of the Indians.

Maximilian admired the accuracy of Karl Bodmer's landscape painting in Germany, observing that Bodmer "could draw what was put in front of him," an obvious advantage for Maximilian's scientific purposes. Maximilian proposed that he would pay Bodmer's expenses to America and back, in return for which the prince would keep what Bodmer produced. Little is known about Bodmer, who was originally from Switzerland. However, what he left behind in his watercolors is clearly the richest source of visual information about the American West from this time, a source that is only partially represented in the *Reise in das innere Nord-America in den Jahren 1832 bis 1834*. Bodmer drew not only Indians but also steamboats on the Mississippi, a great variety of species of American animals and fauna, and many more landscapes than are represented in the published book. Unlike the other painters discussed in this essay, Bodmer was also interested in changes in the landscape as the Maximilian

party moved west, including sights such as the New Harmony community in Indiana. This encompassing interest, as opposed to the more narrowly focused work of McKenney and Catlin, was probably the result of Maximilian's curiosity about the American environment.

Maximilian and Bodmer returned to Germany in 1834, and Maximilian produced his magnificent book seven years later. The plates in the atlas were printed in Paris, and companion texts were published in English, French, and German. The prints were done using the aquatint process, which allowed a depth and warmth that is missing in engravings and lithographs. The aquatint is produced from a copper plate on which a design is engraved and then an aquatint ground applied over the surface of the plate that creates small granular patterns. When the ink is applied and the plate pressed against a sheet of paper, the ink collected in the small granular holes produces a gradual tone background to the image printed by the engraved line.

Though there are a variety of formats, interests, and sentiments displayed in the work of Karl Bodmer,

Thomas McKenney, and George Catlin, they are united in the view that Native American culture was quickly changing and was perhaps imperiled by the march of a Western culture alien to it. They all shared the sense that this was a unique—and possibly last—moment to depict a culture in its purest state. George Catlin saw the Indians as a romantic and pure people who were being degraded by their contacts with white culture. Maximilian viewed the Indians as inferior to the European race but as one that was quickly evolving. Thomas McKenney believed that the Indian race would soon become extinct and was moved to preserve the portraits for posterity. In at least one case, McKenney was right. The year after Catlin and Bodmer stopped off in the Mandan village to paint portraits, customs, and rituals, the entire tribe was wiped out in a smallpox epidemic, leaving the artists' paintings as the only visual record we have of this lost community.

James Gilreath
AMERICAN HISTORY SPECIALIST
RARE BOOK AND SPECIAL COLLECTIONS
LIBRARY OF CONGRESS

NORTH AMERICAN INDIAN PORTFOLIO

BY GEORGE CATLIN

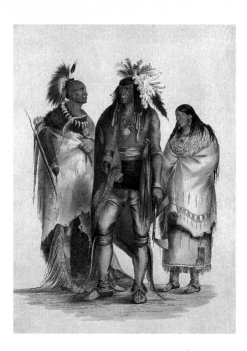

North American Indians

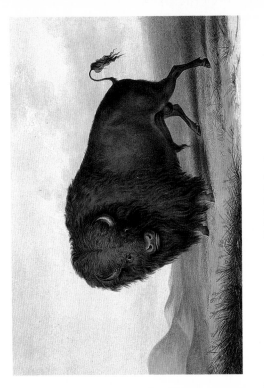

Buffalo Bull, Grazing

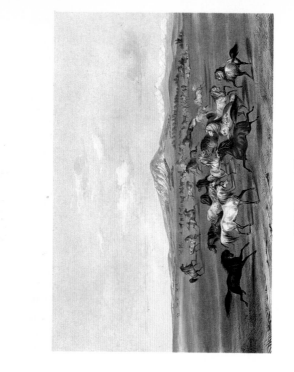

Wild Horses at Play

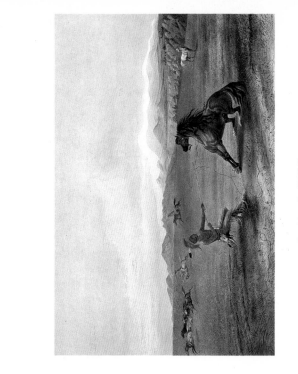

Catching the Wild Horse

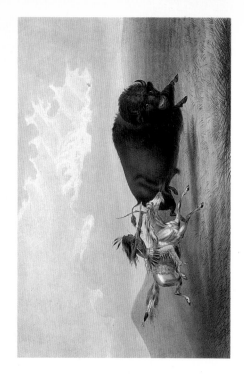

Buffalo Hunt, Chase

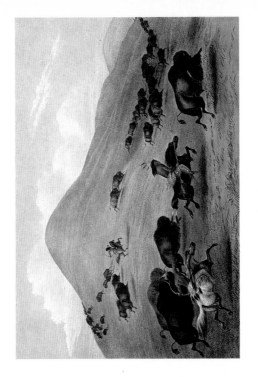

Buffalo Hunt, Chase

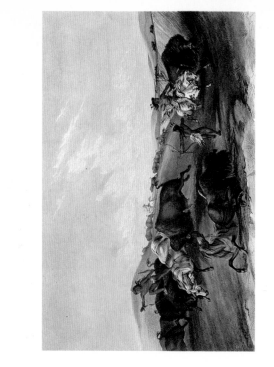

Buffalo Hunt, Chase

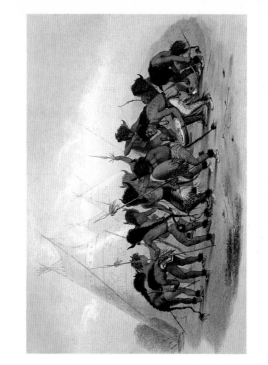

Buffalo Dance

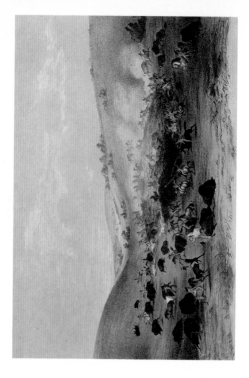

Buffalo Hunt, Surround

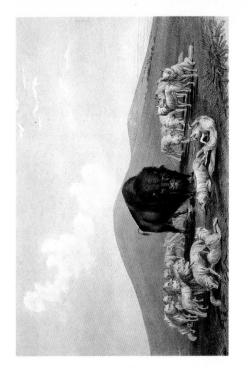

Buffalo Hunt, White Wolves Attacking a Buffalo Bull

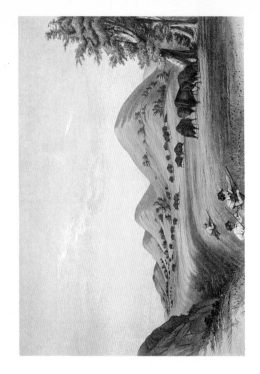

Buffalo Hunt Approaching in a Ravine

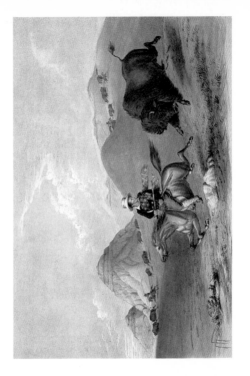

Buffalo Hunt, Chasing Back

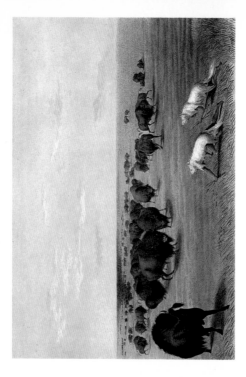

Buffalo Hunt, under the White Wolf Skin

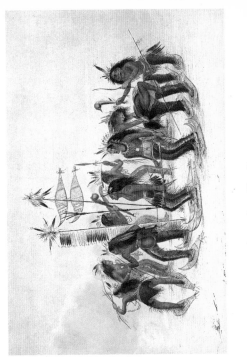

The Snow-Shoe Dance

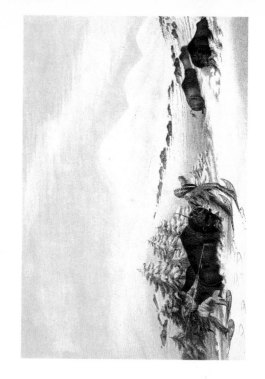

Buffalo Hunt, on Snow Shoes

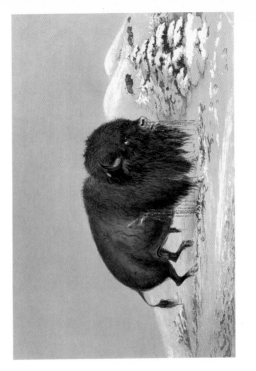

Wounded Buffalo Bull

Dying Buffalo Bull, in Snow Drift

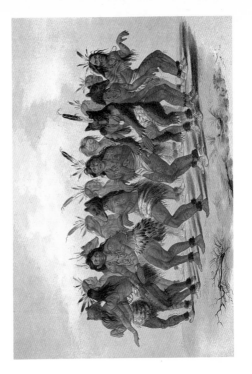

The Bear Dance

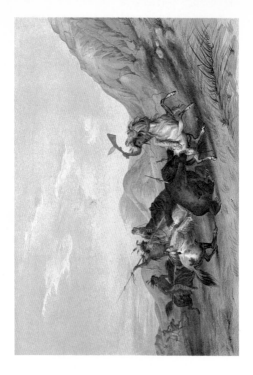

Attacking the Grizzly Bear

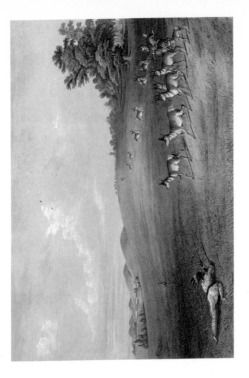

Antelope Shooting

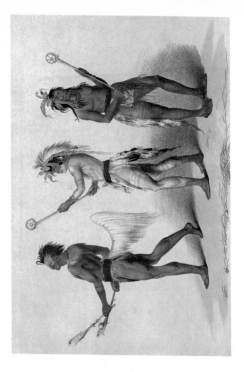

Ball Players

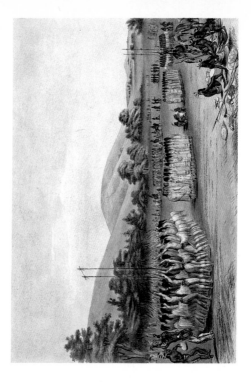

Ball-Play Dance

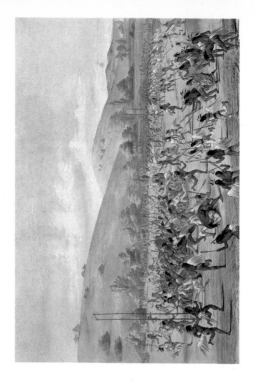

Ball Play

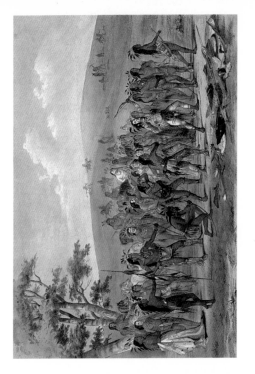

Archery of the Mandans

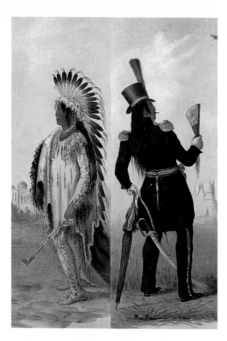

W I - J U N - J O N ,
An Assinneboin Chief, Going to Washington and Returning Home

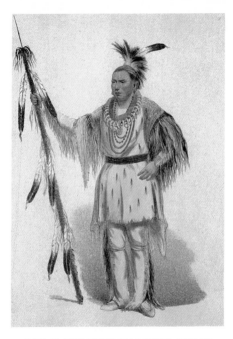

JOC-O-SOT (THE WALKING BEAR),
A Sauk Chief from the Upper Missouri

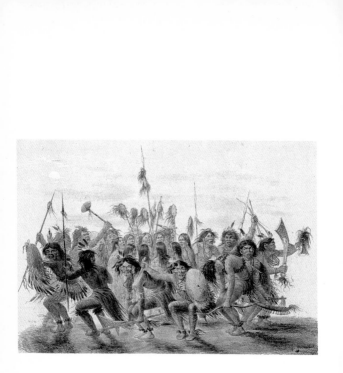

The Scalp Dance

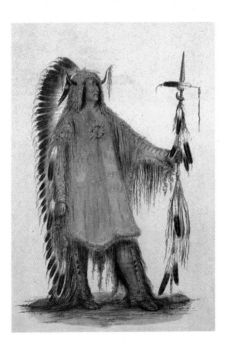

MAH-TO-TOH-PA.
The Mandan Chief

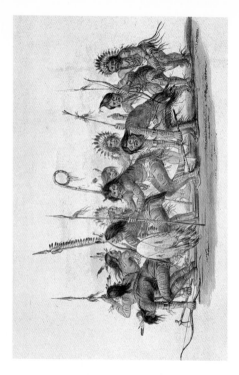

The War Dance

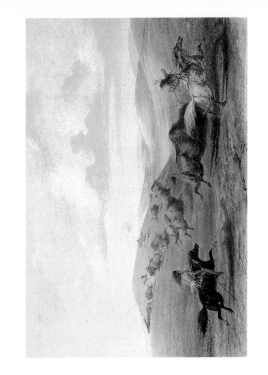

Buffalo Hunting

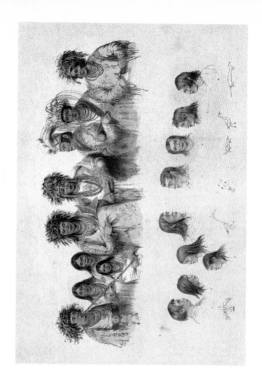

TRAVELS IN THE INTERIOR OF NORTH AMERICA BETWEEN 1832 AND 1834

BY KARL BODMER

VIGNETTES

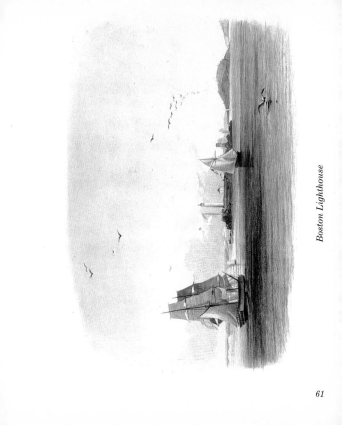

Boston Lighthouse

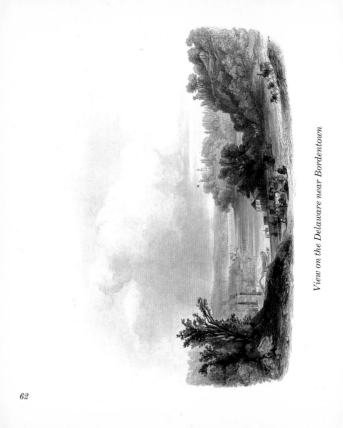

View on the Delaware near Bordentown

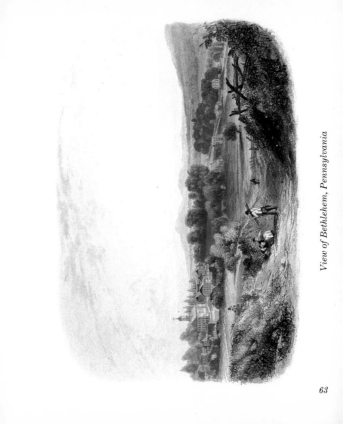

View of Bethlehem, Pennsylvania

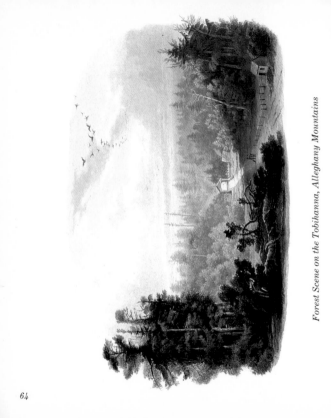

Forest Scene on the Tobihanna, Alleghany Mountains

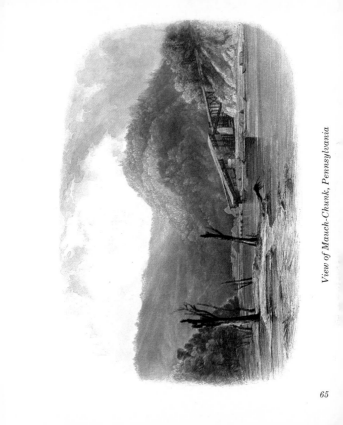

View of Mauch-Chunk, Pennsylvania

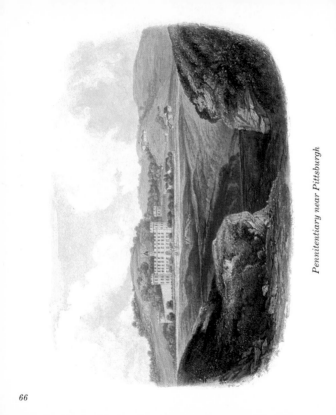

Pennitentiary near Pittsburgh

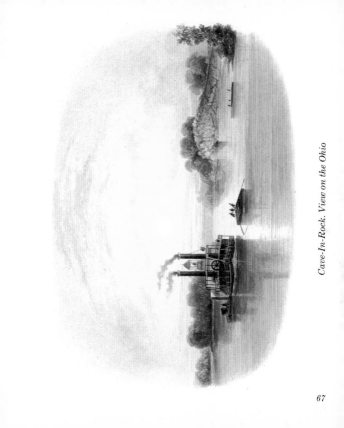

Cave-In-Rock. View on the Ohio

Cutoff-River. Branch of the Wabash

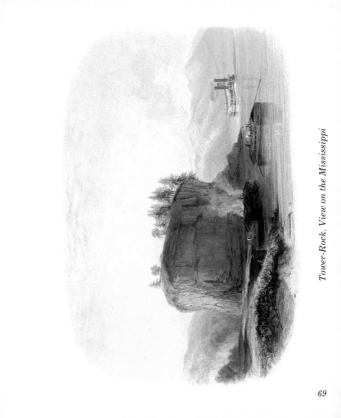

Tower-Rock. View on the Mississippi

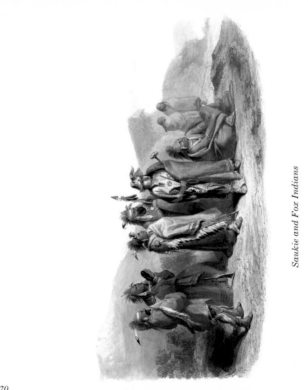

Saukie and Fox Indians

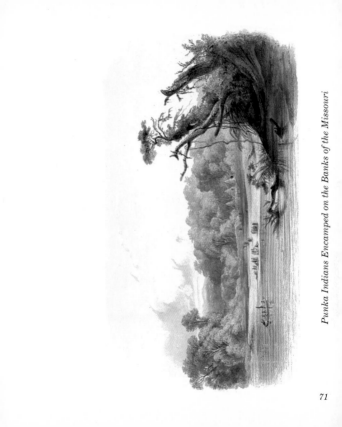

Punka Indians Encamped on the Banks of the Missouri

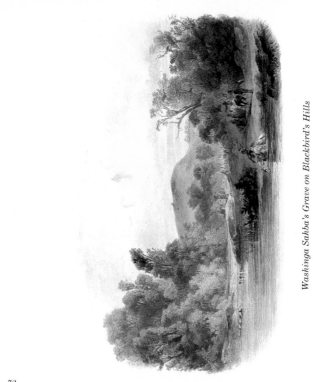

Washinga Sahba's Grave on Blackbird's Hills

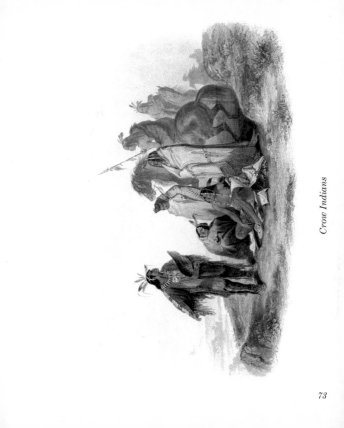

Crow Indians

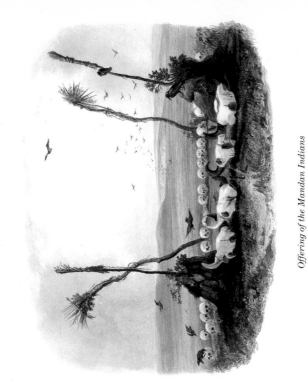

Offering of the Mandan Indians

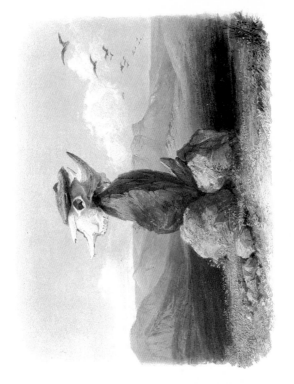

Magic Pile Erected by the Assiniboin Indians

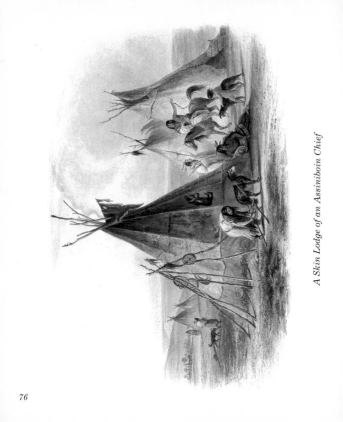

A Skin Lodge of an Assiniboin Chief

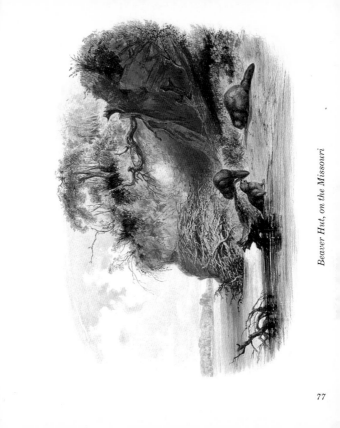

Beaver Hut, on the Missouri

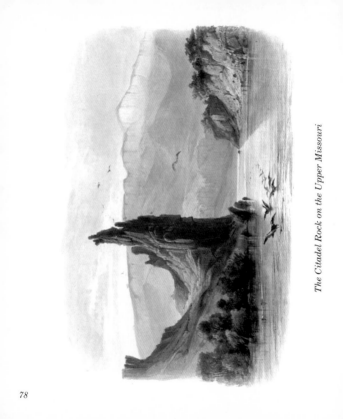

The Citadel Rock on the Upper Missouri

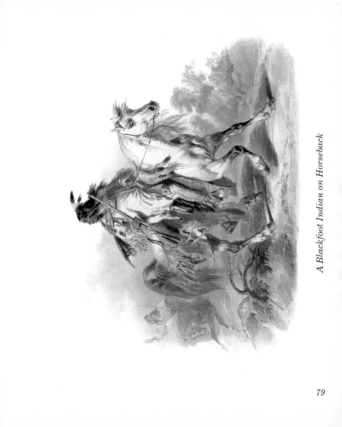

A Blackfoot Indian on Horseback

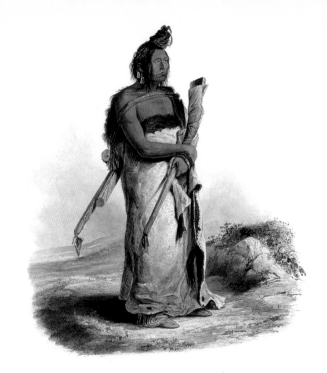

MEXKEMAHUASTAN.
Chief of the Gros-ventres des Prairies

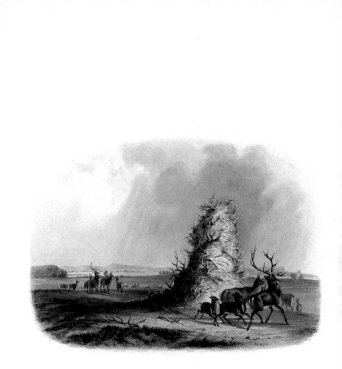

The Elkhorn Pyramid, on the Upper Missouri

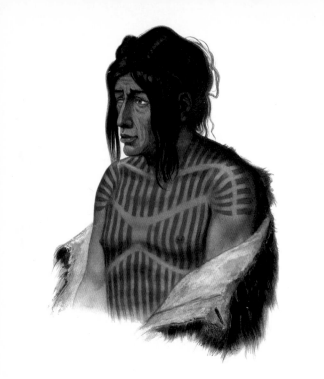

MAHSETTE-KUIUAB.
Chief of the Cree Indians

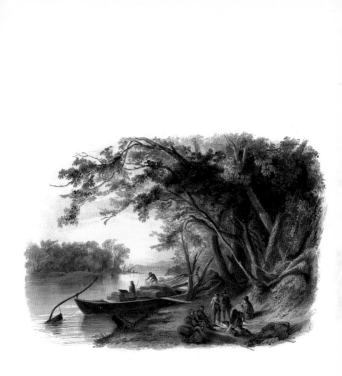

Encampment of the Travellers, on the Missouri

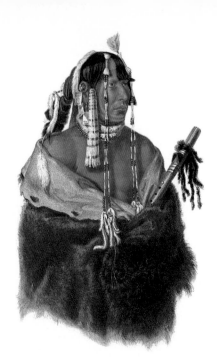

MÁNDEH-PÁHCHU.
A Young Mandan Indian

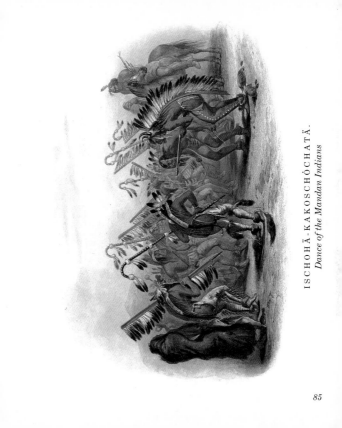

ISCHOHÄ-KAKOSCHÔCHATÄ.
Dance of the Mandan Indians

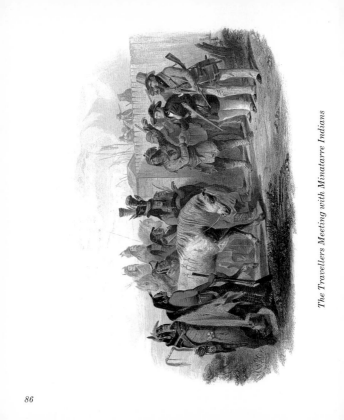

The Travellers Meeting with Minatarre Indians

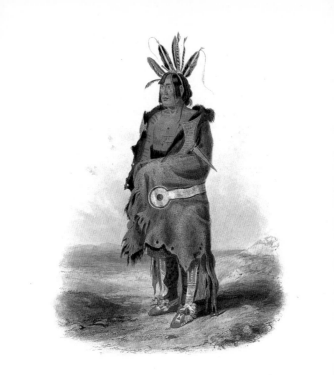

PACHTÜWA-CHTÄ.

An Arrikkara Warrior

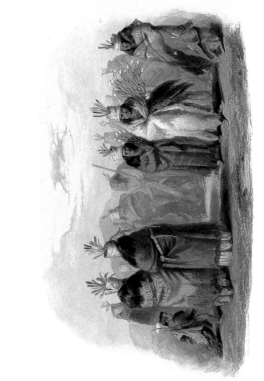

PTIHN-TAK-OCHATÄ.
Dance of the Mandan Women

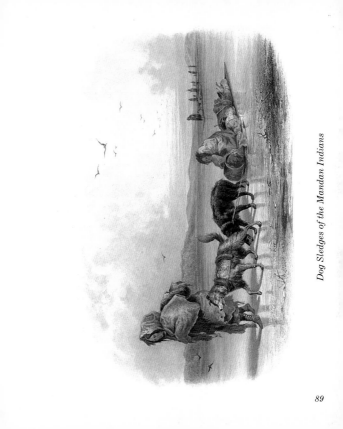

Dog Sledges of the Mandan Indians

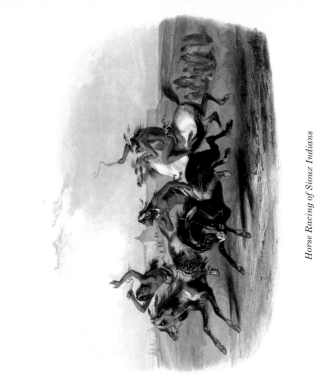

Horse Racing of Sioux Indians

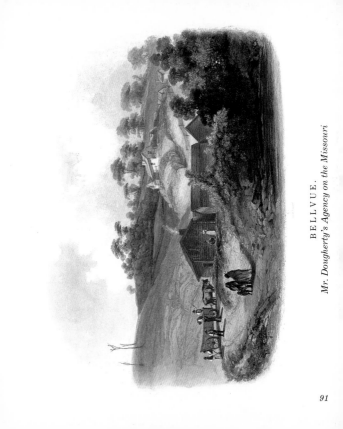

BELLVUE.

Mr. Dougherty's Agency on the Missouri

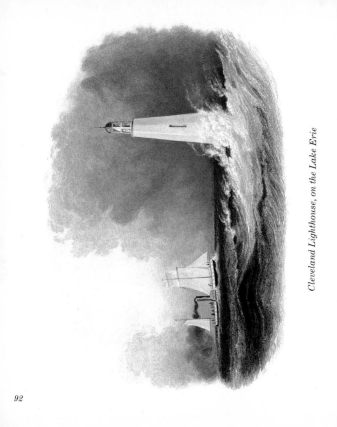

Cleveland Lighthouse, on the Lake Erie

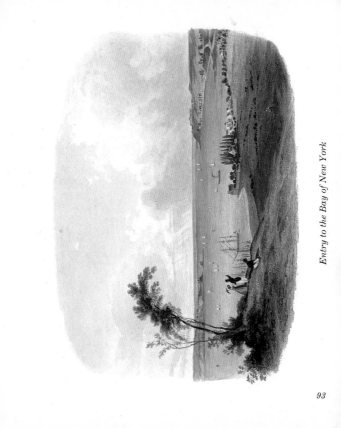

Entry to the Bay of New York

TABLEAUX

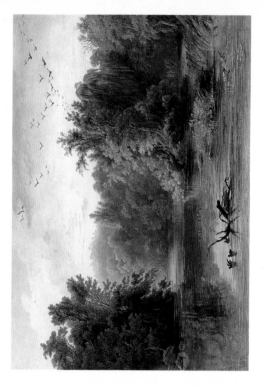

Forest Scene on the Lehigh

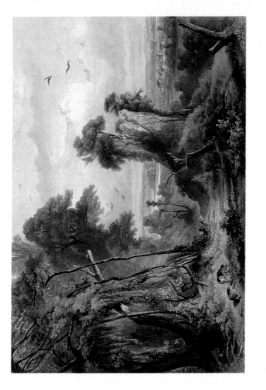

New Harmony, on the Wabash

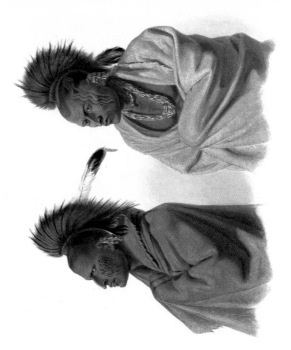

Mässika & Wakusásse

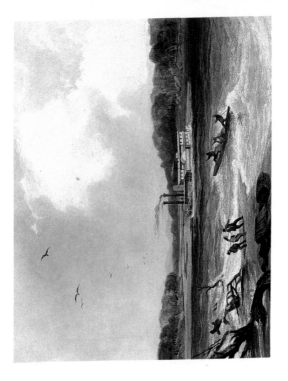

The Steamer Yellowstone

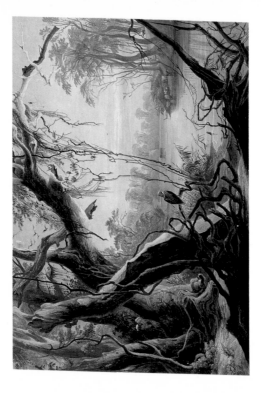

Mouth of the Fox River, Indiana

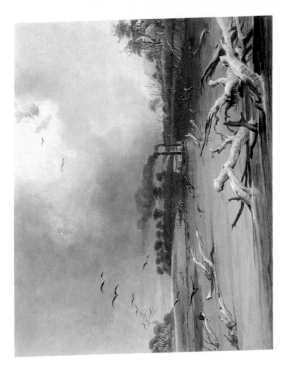

S N A G S.
Sunken Trees on the Missouri

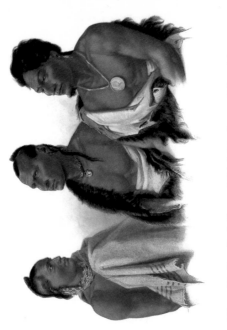

Missouri Indian, Oto Indian and Chief of the Puncas (left to right)

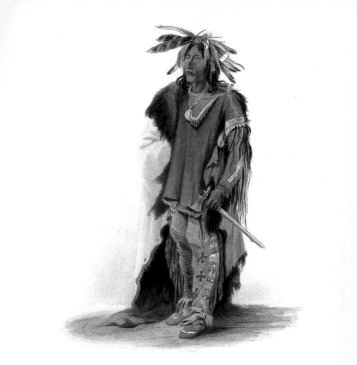

WAHK-TA-GE-LI.
A Sioux Warrior

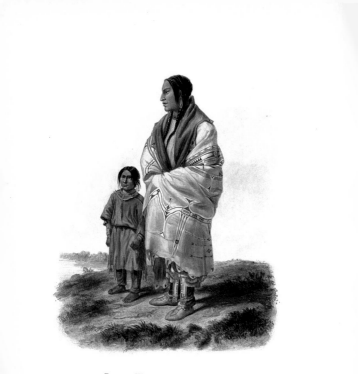

Dacota Woman and Assiniboin Girl

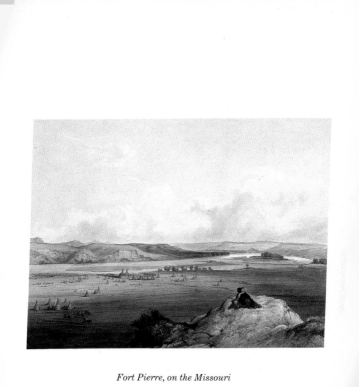

Fort Pierre, on the Missouri

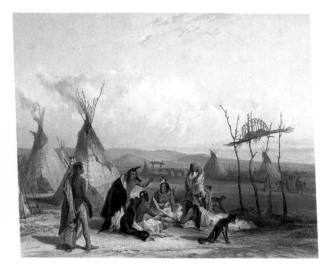

Funeral Scaffold of a Sioux Chief

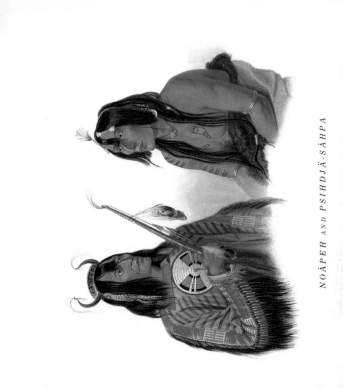

NOÁPEH AND PSIHDJÄ-SÁHPA

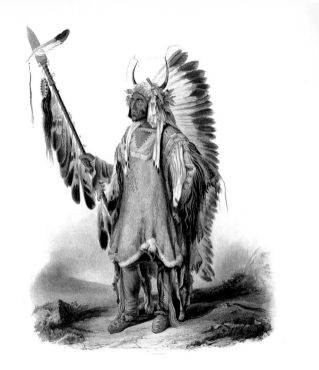

MATO-TOPE.
A Mandan Chief

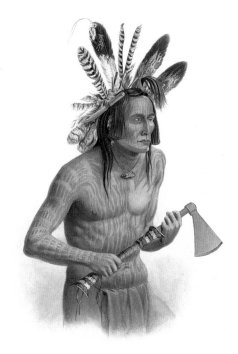

MATO-TOPE
Adorned with the Insignia of his Warlike Deeds

Fort Clark, on the Missouri

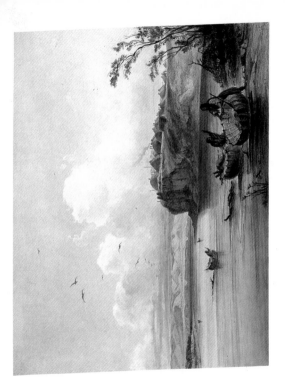

MIH-TUTTA-HANGKUSCH.
A Mandan Village

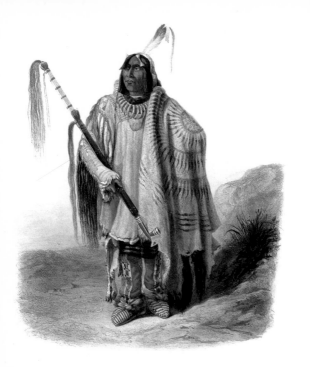

PEHRISKA-RUHPA

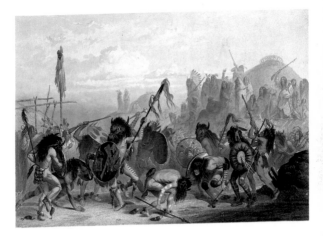

Bison Dance of the Mandan Indians

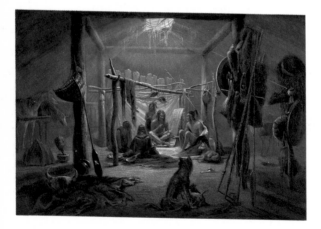

The Interior of the Hut of a Mandan Chief

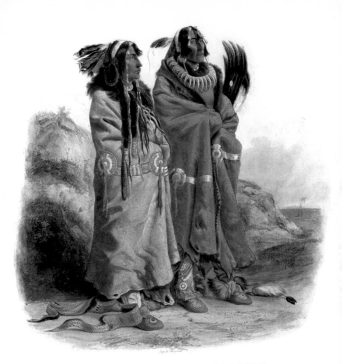

SIH-CHIDA & MAHCHSI-KAREHDE.
Mandan Indians

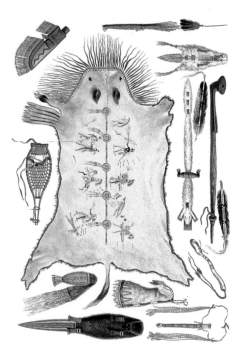

Indian Utensils and Arms

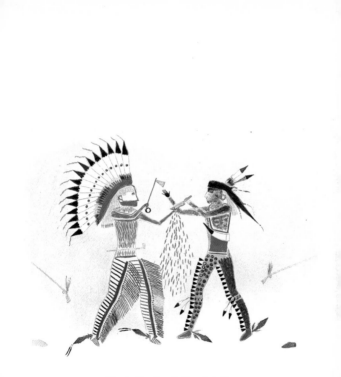

Facsimile of an Indian Painting

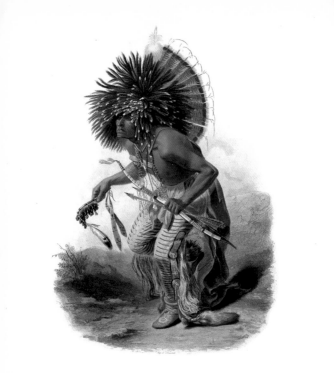

PEHRISKA-RUHPA.

Moennitarri Warrior in the Costume of the Dog Danse

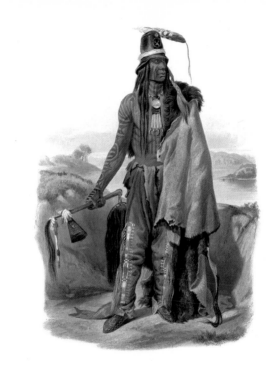

ABDIH-HIDDISCH.

A Minatarre Chief

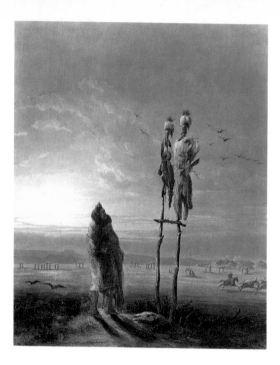

Idols of the Mandan Indians

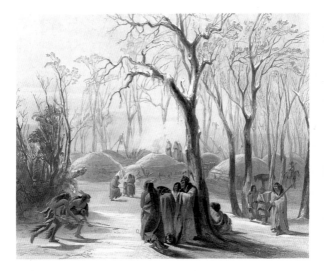

Winter Village of the Minatarres

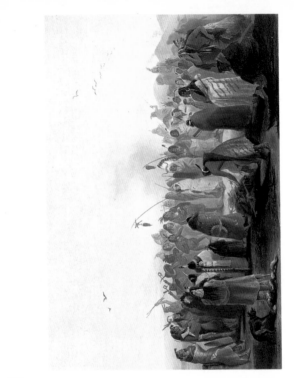

Scalp Dance of the Minatarres

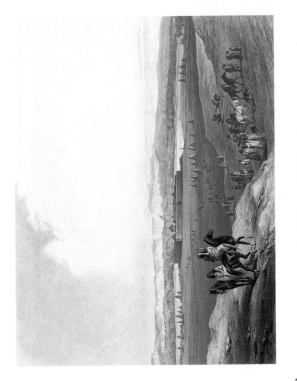

Fort Union, on the Missouri

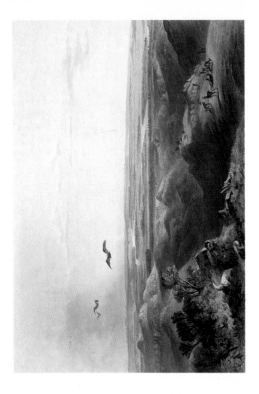

Junction of the Yellowstone with the Missouri

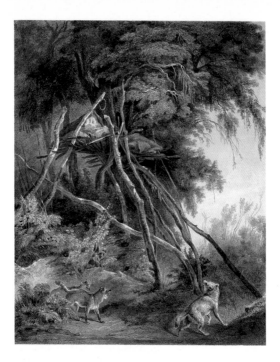

Tombs of the Assiniboin Indians on Trees

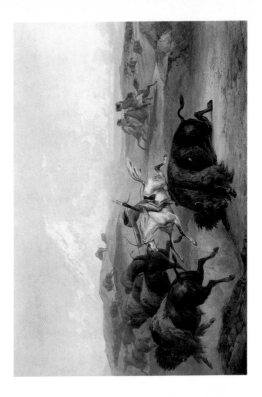

Indians Hunting the Bison

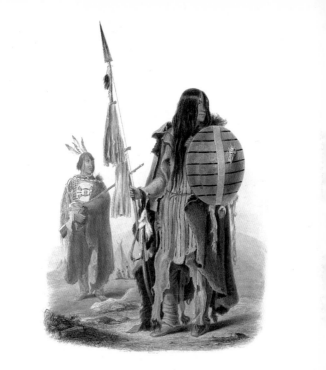

Assiniboin Indians

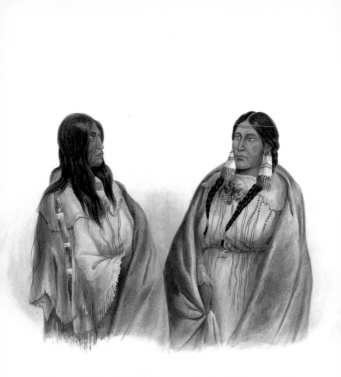

Woman of the Snake Tribe. Woman of the Cree Tribe (left to right)

Remarkable Hills on the Upper Missouri

Remarkable Hills on the Upper Missouri

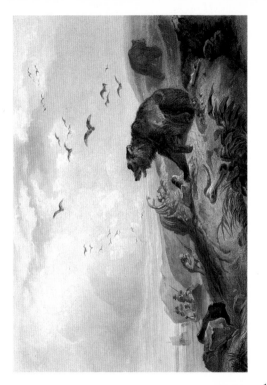

Hunting of the Grizzly Bear

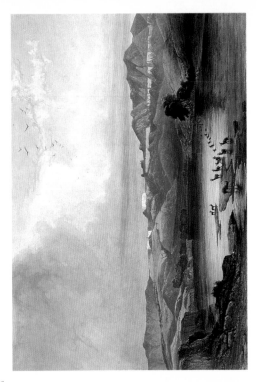

The White Castels, on the Upper Missouri

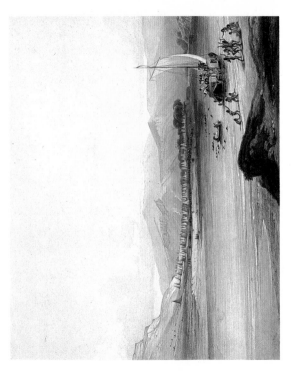

Camp of the Gros Ventres of the Prairies

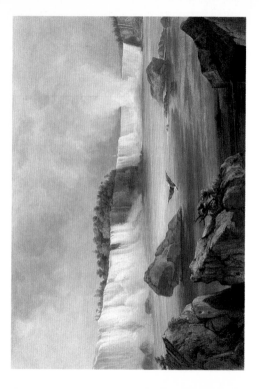

Niagara Falls

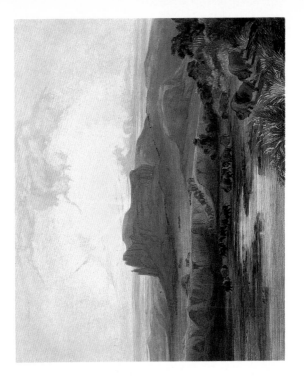

Herd of Bisons on the Upper Missouri

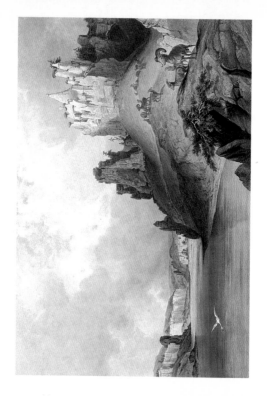

View of the Stone Walls, on the Upper Missouri

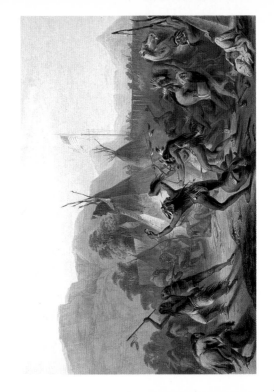

Fort Mackenzie, 28th of August, 1833

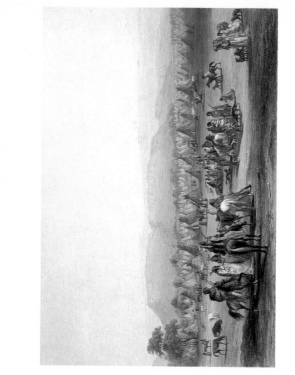

Encampment of the Piekann Indians

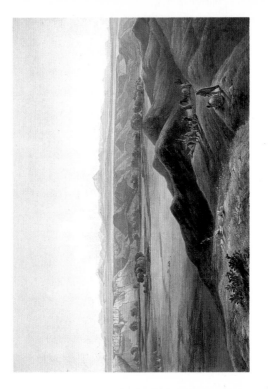

View of the Rocky Mountains

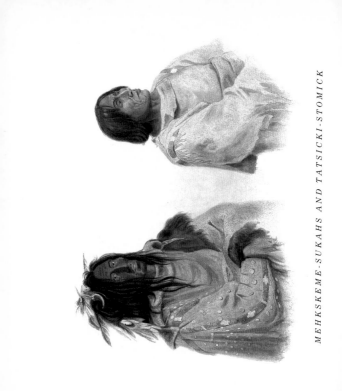

MEHKSKEME-SUKAHS AND TATSICKI-STOMICK

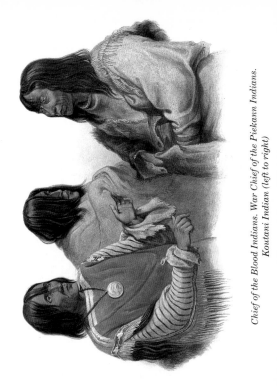

Chief of the Blood Indians. War Chief of the Piekann Indians. Koutani Indian (left to right)

141

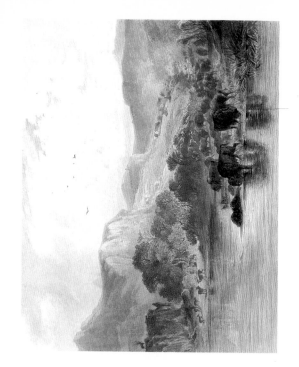

Herds of Bison and Elk

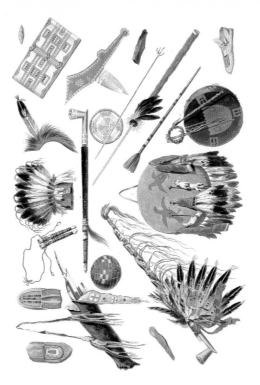

Indian Utensils and Arms

HISTORY OF THE INDIAN TRIBES OF NORTH AMERICA, VOLUMES 1-3

BY THOMAS L. MCKENNEY
AND JAMES HALL

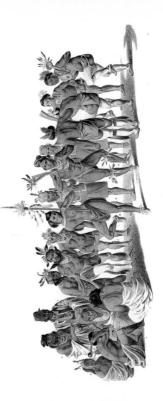

War Dance of the Sauks and Foxes

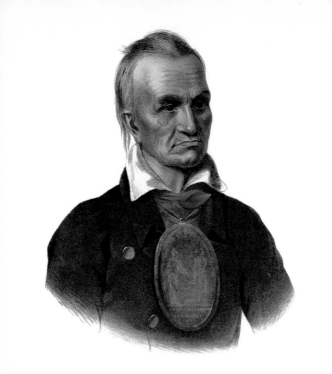

RED JACKET.
Seneca War Chief

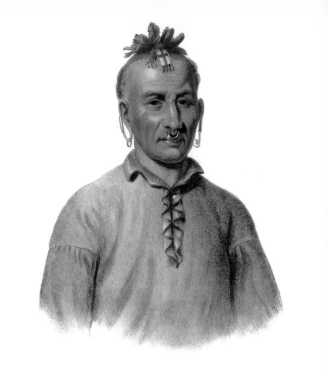

KISH-KALLO-WA.
Shawnee Chief

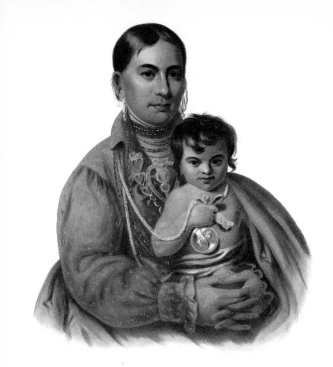

MO-HON-GO.

Osage Woman

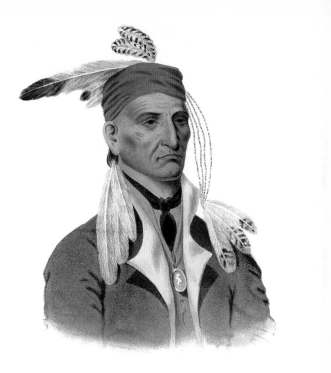

SHIN-GA-BA-W'OSSIN.

Image stone

149

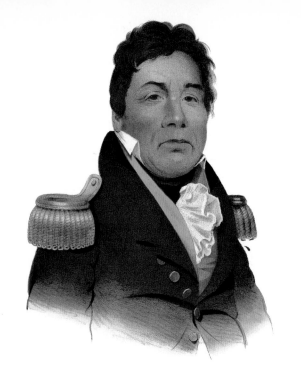

PUSH-MA-TA-HA.
Chactan Warrior

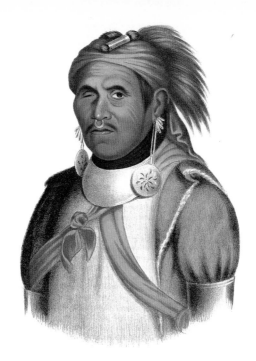

TENS-KWAU-TA-WAW. OR THE OPEN DOOR.

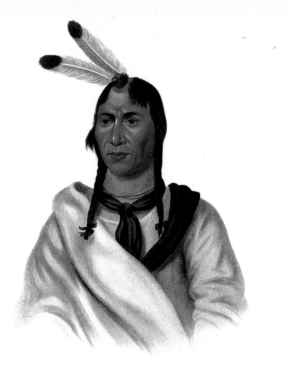

ESH-TAH-HUM-LEAH. OR THE SLEEPY EYE.

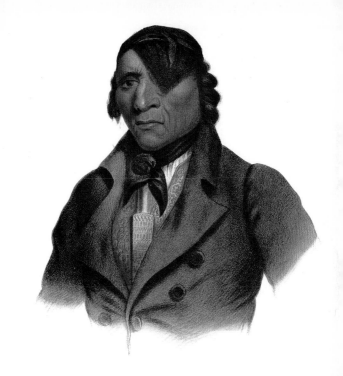

WAA-PA-SHAW.
Sioux Chief

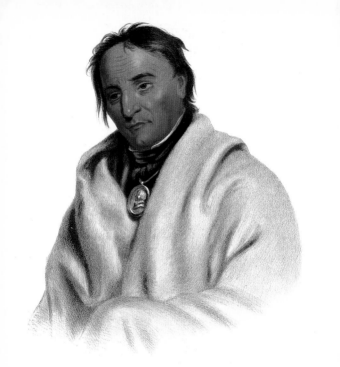

META-KOOSEGA. PURE TOBACCO.
A Chippeway Warrior

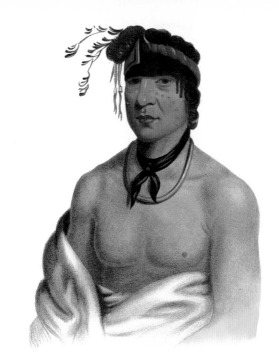

WESH CUBB. OR THE SWEET.
A Chippeway Chief

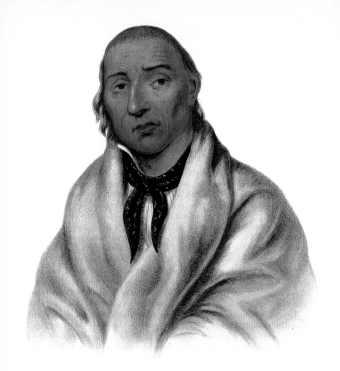

LITTLE CROW.
A Sioux Chief

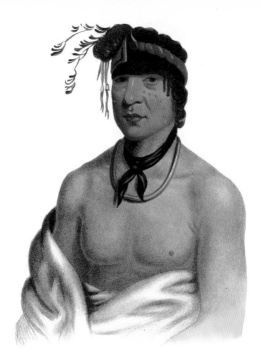

WESH CUBB. OR THE SWEET.
A Chippeway Chief

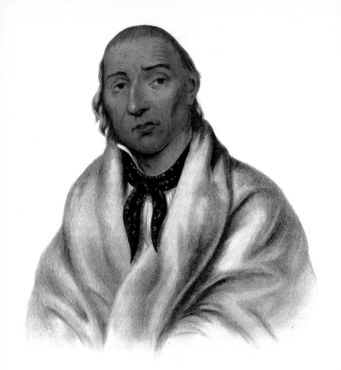

LITTLE CROW.
A Sioux Chief

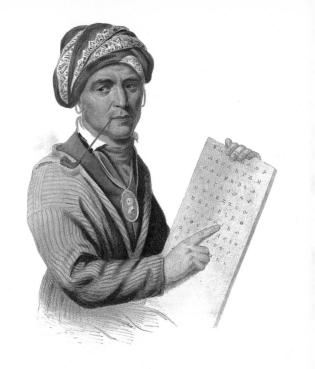

SE-QUO-YAH

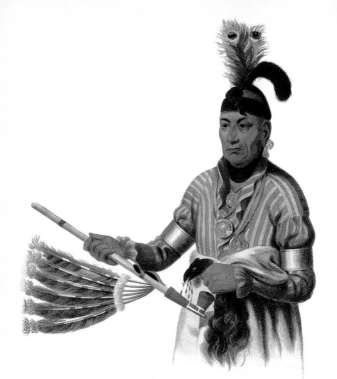

NAW-KAW. OR WOOD

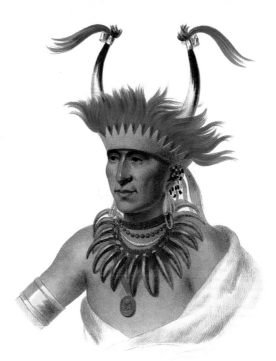

CHON-MAN-I-CASE.
An Otto Half Chief

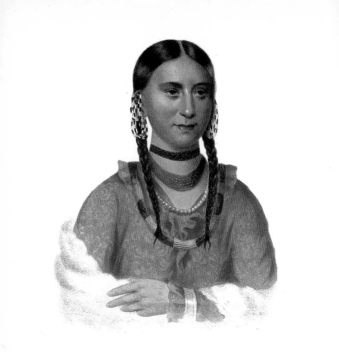

HAYNE HUDJIHINI. THE EAGLE OF DELIGHT.

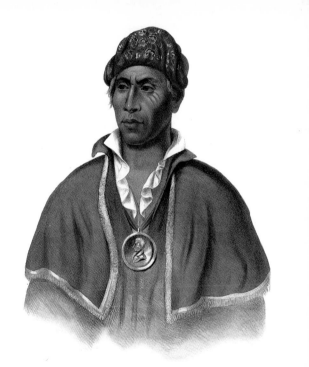

QUA-TA-WA-PEA.
A Shawanee Chief

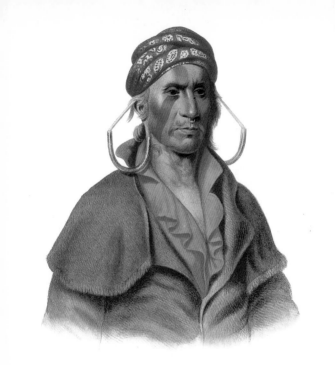

PAYTA KOOTHA.
A Shawanee Warrior

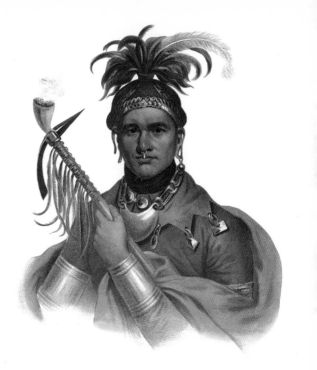

KI-ON-TWOG-KY. OR CORNPLANT.

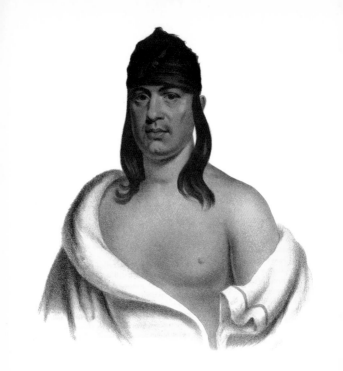

PAH-SHE-PAH-HOW

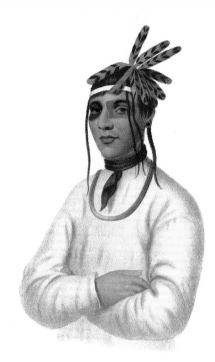

CAA-TOU-SEE.
An Ojibway

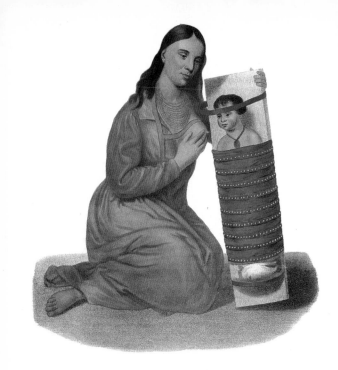

Chippeway Squaw & Child

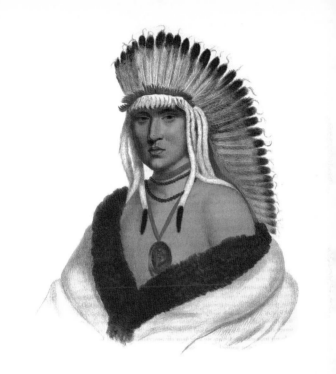

PETALESHAROO.
A Pawnee Brave

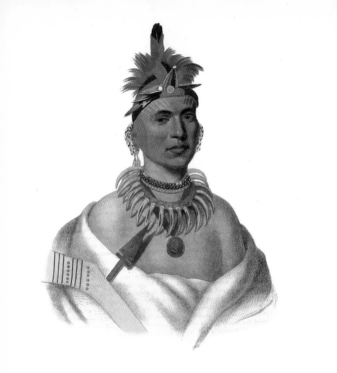

CHON-CA-PE

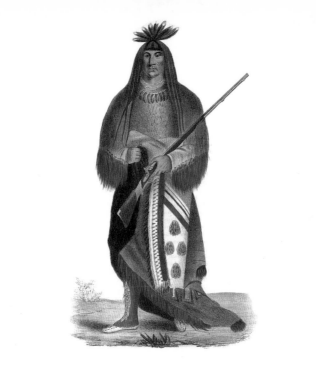

WA-NA-TA. THE CHARGER.
Grand Chief of the Sioux

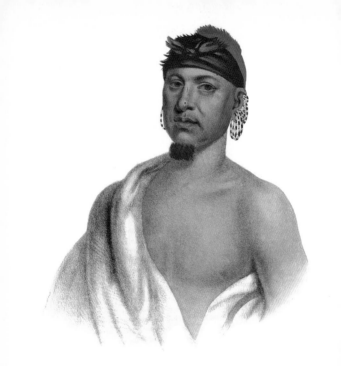

PEAH-MAS-KA.
A Musquawkee Chief

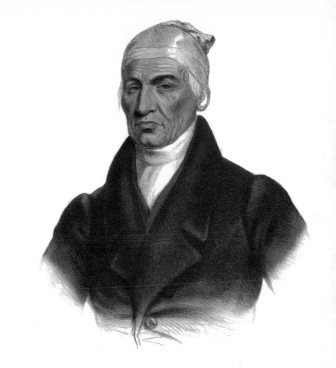

CA-TA-HE-CAS-SA. BLACK HOOF.
Principal Chief of the Shawanees

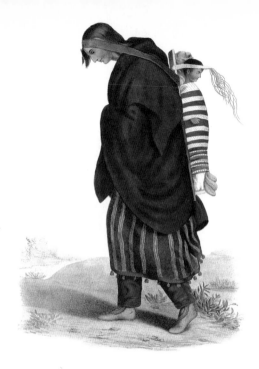

Chippeway Squaw & Child

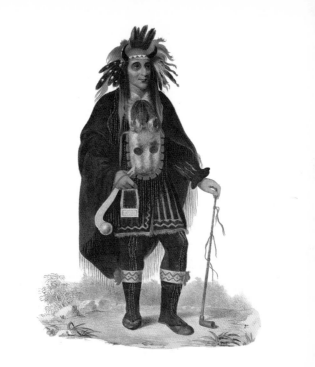

OKEE-MAAKEE-QUID.

A Chippeway Chief

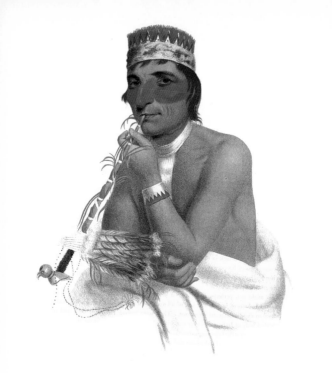

WA-EM-BOESH-KAA.
A Chippeway Chief

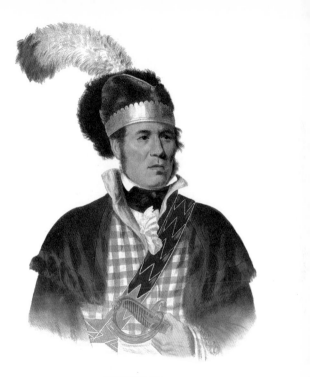

MCINTOSH.

A Creek Chief

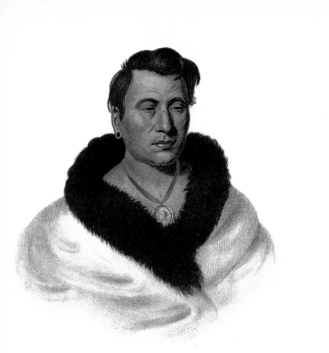

ONG-PA-TON-GA. OR THE BIG ELK.
Chief of the Omahas

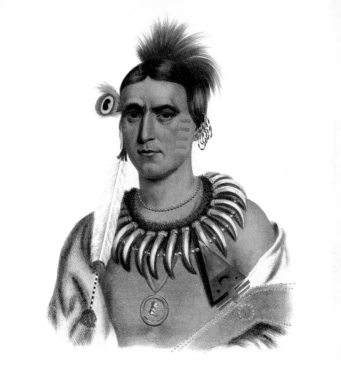

MA-HAS-KAH. OR WHITE CLOUD.
An Ioway Chief

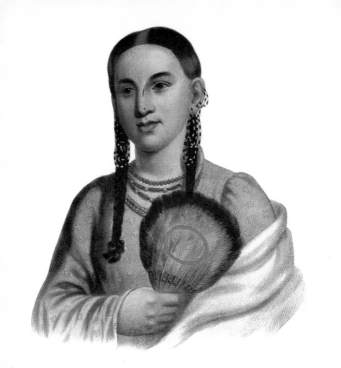

RANT-CHE-WAI-ME. FEMALE FLYING PIGEON.

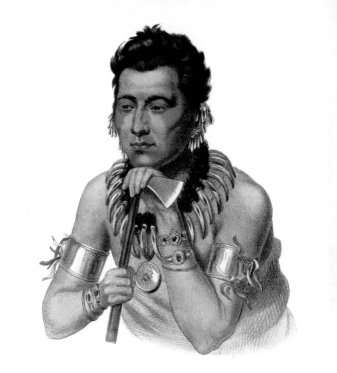

YOUNG MA-HAS-KAH.

Chief of the Ioways

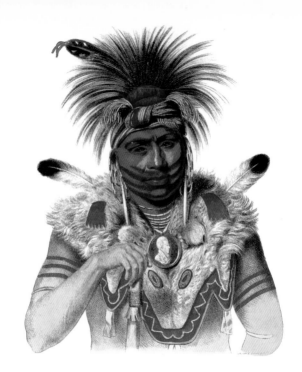

NE-SOU-A-QUOIT.
A Fox Chief

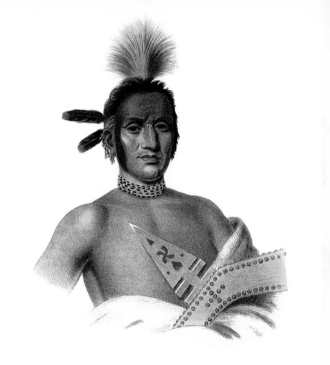

MOA-NA-HON-GA.

An Ioway Chief

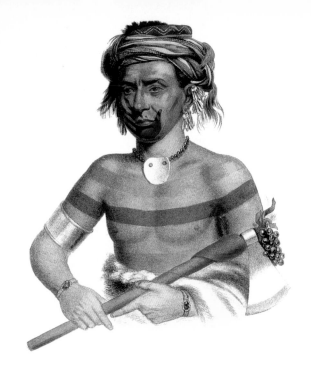

SHAU-HAU-NAPO-TINIA.
An Ioway Chief

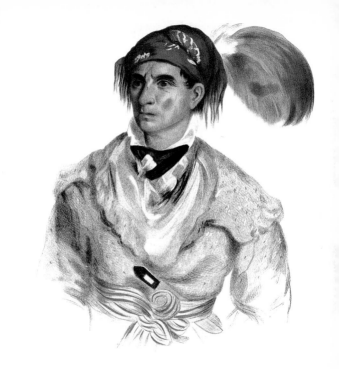

TAH-CHEE.
A Cherokee Chief

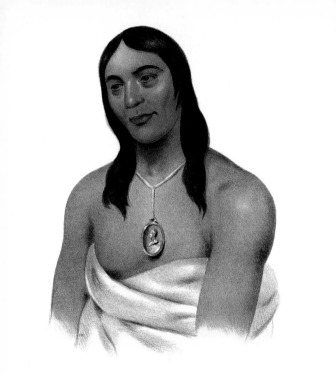

A-NA-CAM-E-GISH-CA.

A Chippeway Chief

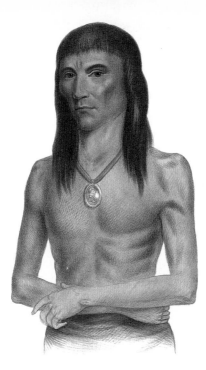

WA-BISH-KEE-PE-NAS. THE WHITE PIGEON.

A Chippewa

185

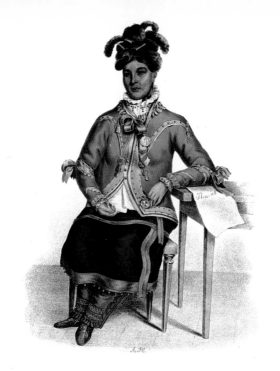

TSHUSICK.

An Ojibway Woman

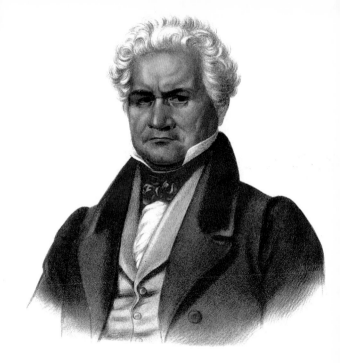

MAJOR RIDGE.
A Cherokee Chief

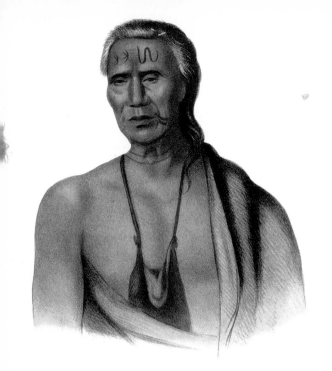

LAP-PA-WIN-SOE.
A Delaware Chief

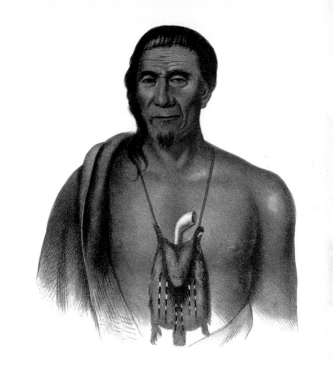

TISH-CO-HAN.
A Delaware Chief

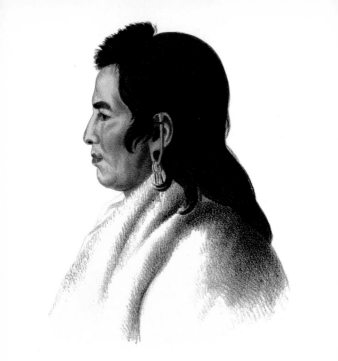

SHA-HA-KA.
A Mandan Chief

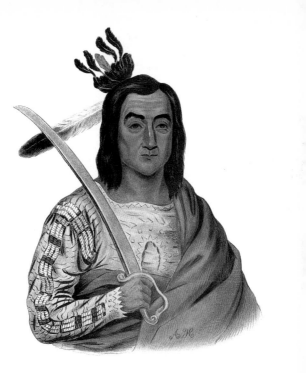

MON-KA-USH-KA.
A Sioux Chief

191

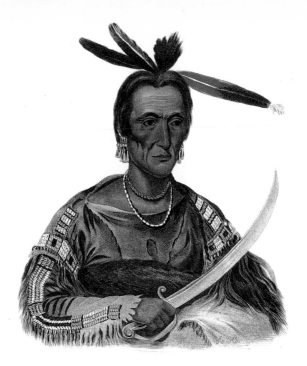

TO-KA-CON.
A Sioux Chief

Hunting the Buffaloe

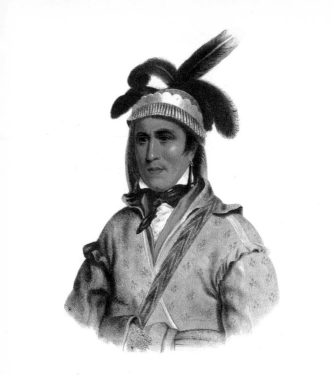

OPOTHLE YOHOLO.
A Creek Chief

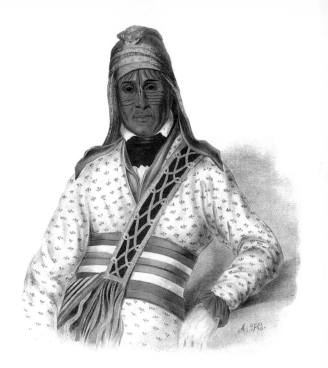

YOHOLO-MICCO.
A Creek Chief

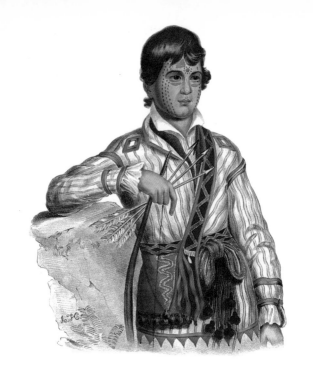

MISTIPPEE

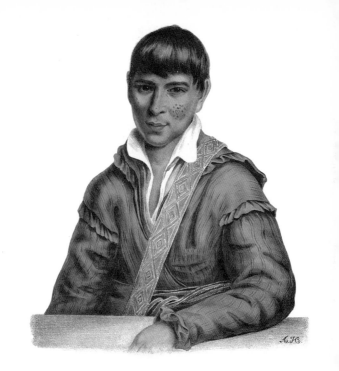

PADDY CARR.
Creek Interpreter

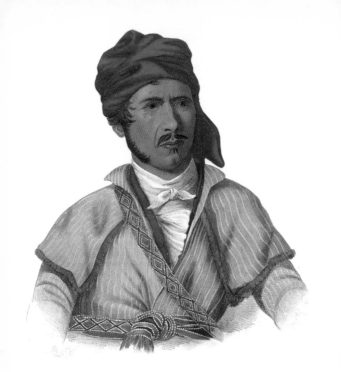

TIMPOOCHEE BARNARD.

An Uchee Warrior

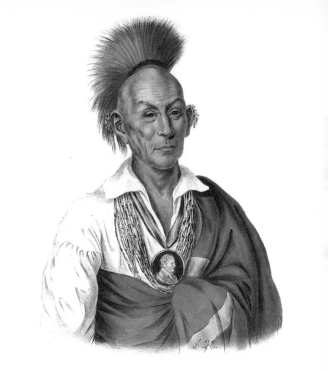

MA-KA-TAI-ME-SHE-KIA-KIAH. OR BLACK HAWK.
A Saukie Brave

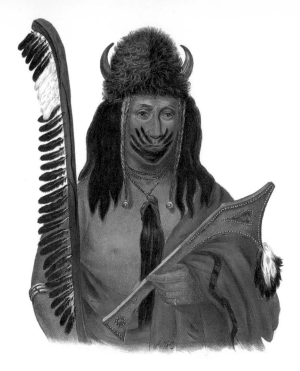

KISH-KE-KOSH.
A Fox Brave

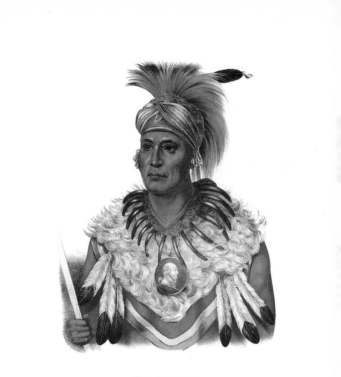

WA-PEL-LA.
Chief of the Musquakees

201

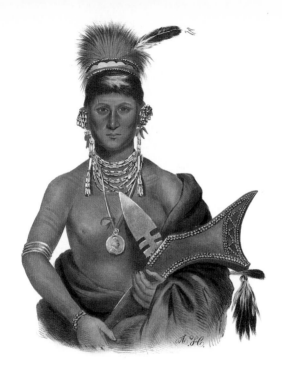

AP-PA-NOO-SE.
Saukee Chief

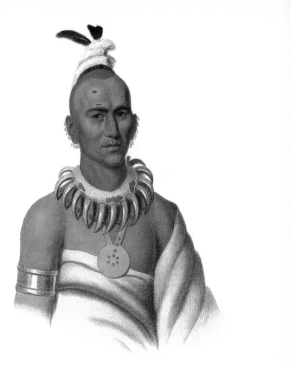

TAI-O-MAH.

A Musquakee Brave

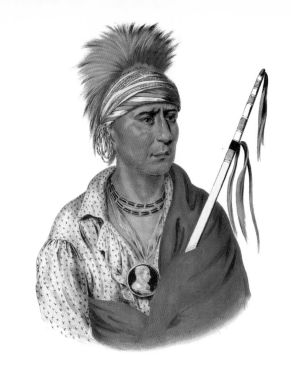

NOT-CHI-MI-NE.
An Ioway Chief

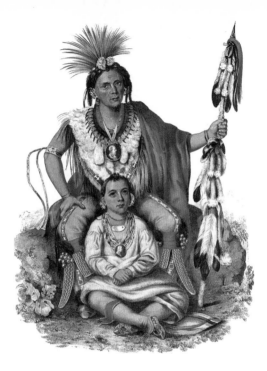

KEOKUK.
Chief of the Sacs & Foxes

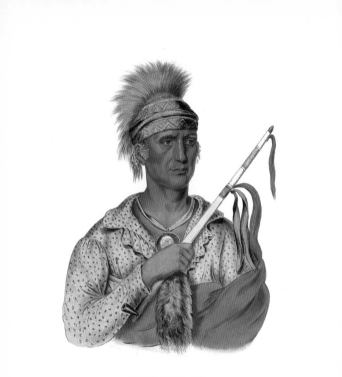

NE-O-MON-NE.
An Ioway Chief

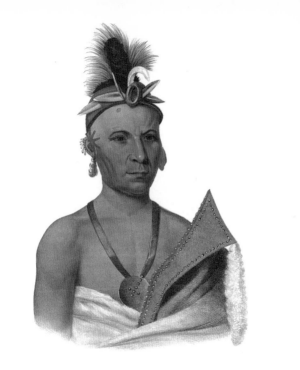

KEE-SHES-WA.
A Fox Chief

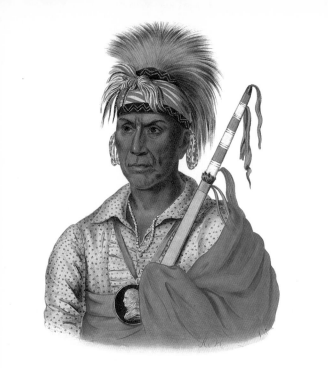

TAH-RO-HON.
An Ioway Warrior

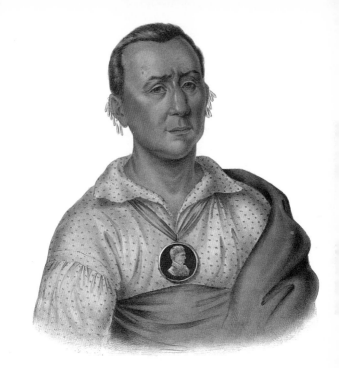

WAT-CHE-MON-NE.
An Ioway Chief

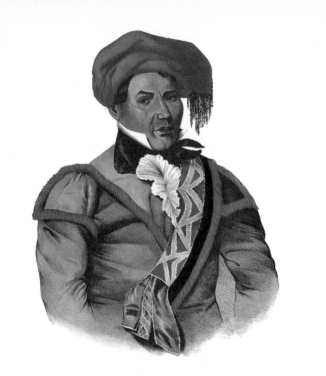

TUSTENNUGGEE EMATHLA. OR JIM BOY.
A Creek Chief

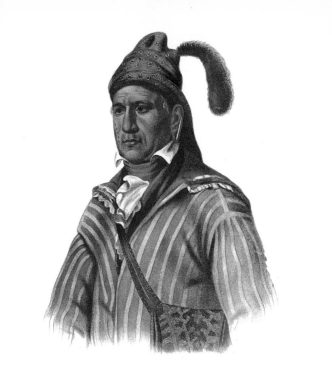

ME-NA-WA.
A Creek Warrior

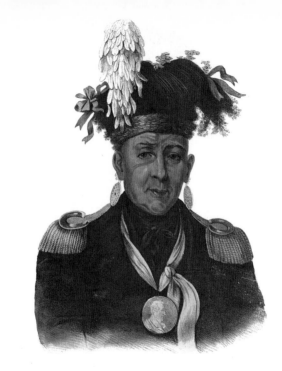

WA-BAUN-SEE.
A Pottawatomie Chief

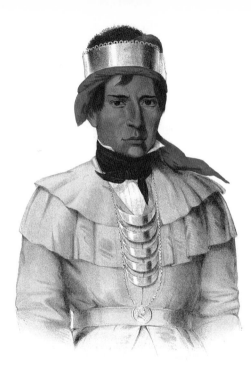

CHITTEE YOHOLO.

A Seminole Chief

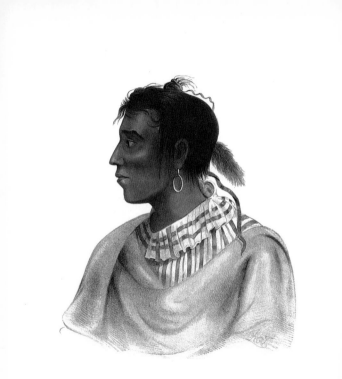

ME-TE-A.
A Pottawatomie Chief

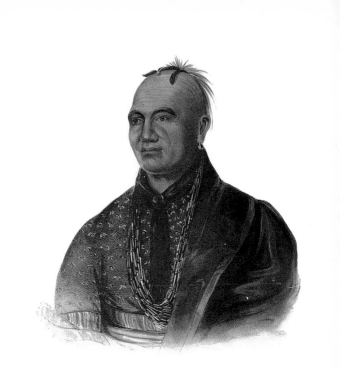

THAYENDANEGEA.
The Great Captain of the Six Nations

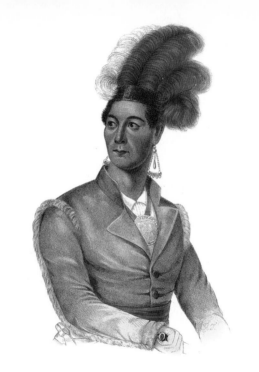

AHYOUWAIGHS.
Chief of the Six Nations

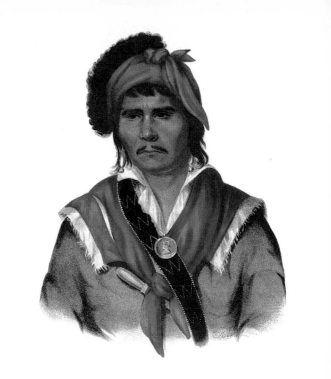

NEA-MATH-LA.
A Seminole Chief

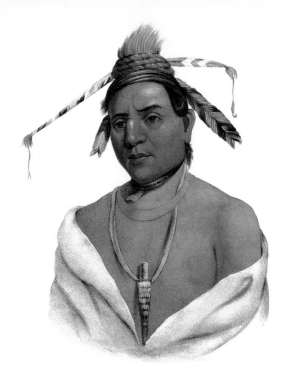

MAR - KO - ME - TE.
A Menomene Brave

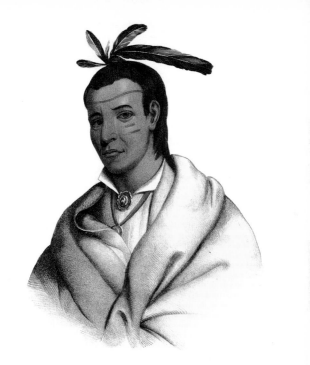

A-MIS-QUAM.

A Winnebago Brave

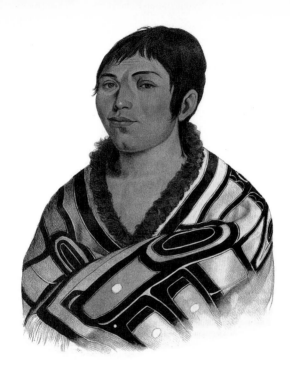

STUM-MA-NU.
A Flat-Head Boy

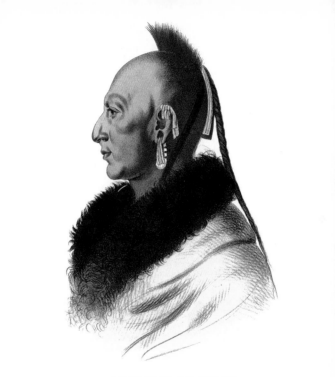

LE SOLDAT DU CHENE.

An Osage Chief

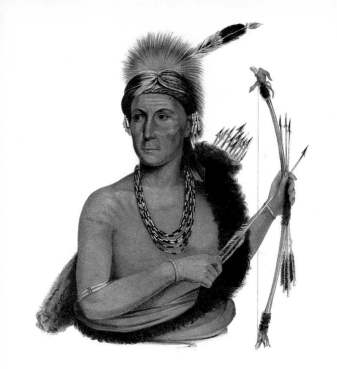

POW-A-SHEEK.
A Fox Chief

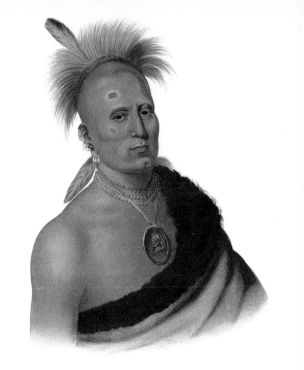

SHAR-I-TAR-ISH.
A Pawnee Chief

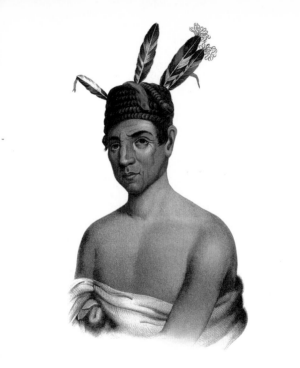

WA-KAWN-HA-KA.
A Winnebago Chief

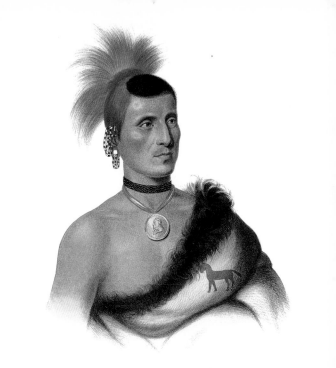

PES-KE-LE-CHA-CO.
A Pawnee Chief

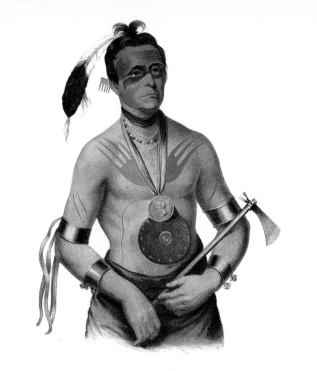

HOO-WAN-NE-KA.
A Winnebago Chief

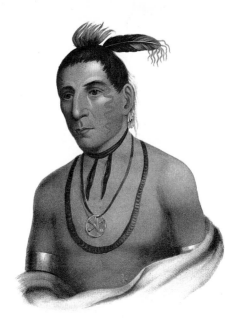

WA-KAWN.
A Winnebago Chief

227

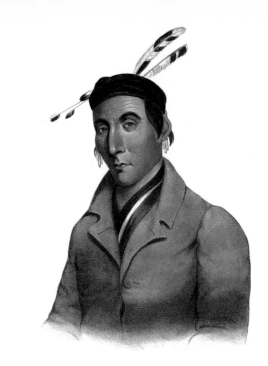

KA·TA·WA·BE·DA.
A Chippeway Chief

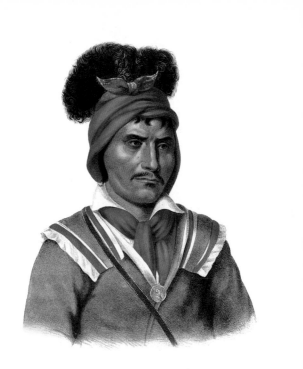

FOKE-LUSTE-HAJO.
A Seminole

229

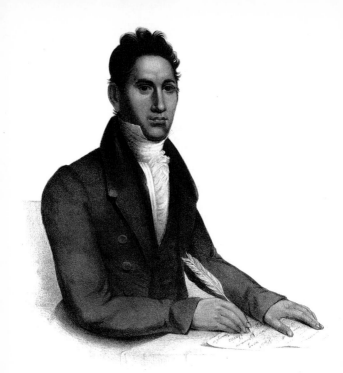

JOHN RIDGE.
A Cherokee

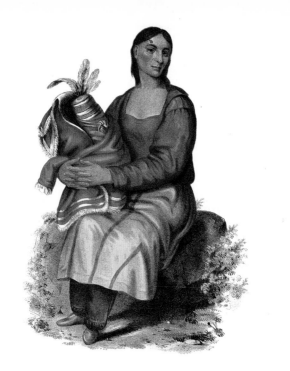

A Chippeway Widow

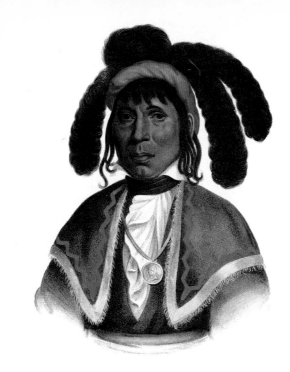

MICANOPY.

A Seminole Chief

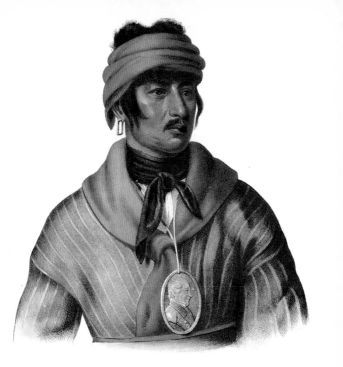

SE-LOC-TA.
A Creek Chief

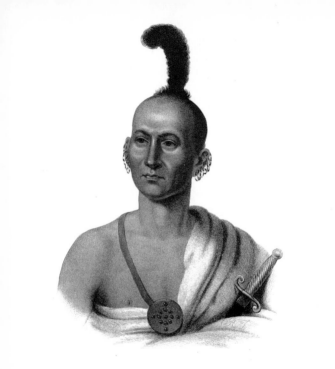

KAI-POL-E-QUAH.
White Nosed Fox

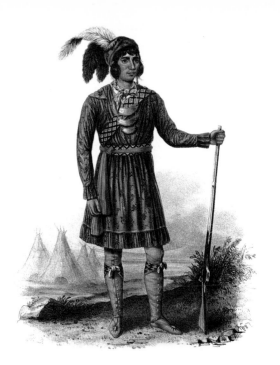

ASEOLA.

A Seminole Leader

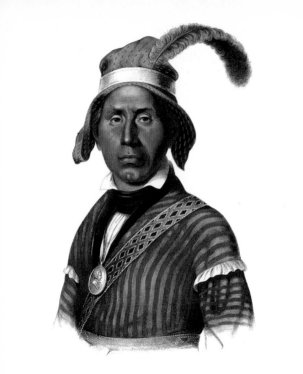

YAHA-HAJO.
A Seminole Chief

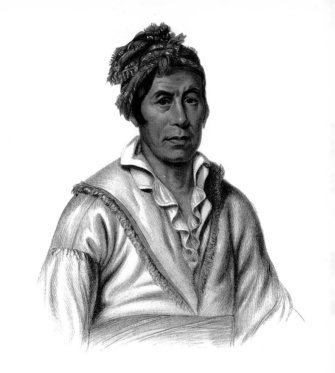

SPRING FROG.
A Cherokee Chief

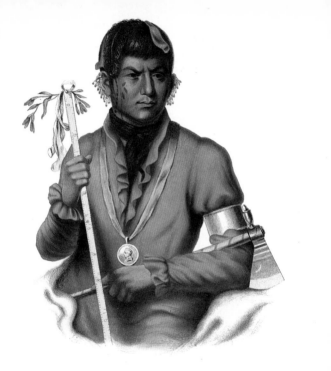

TSHI-ZUN-HAU-KAU.
A Winnebago

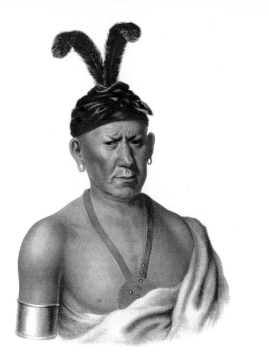

WAKECHAI.
A Saukie Chief

KA-NA-PI-MA.
An Ottowa Chief

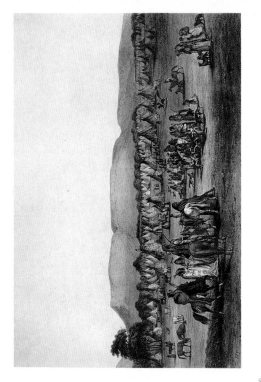

Encampment of the Piekann Indians

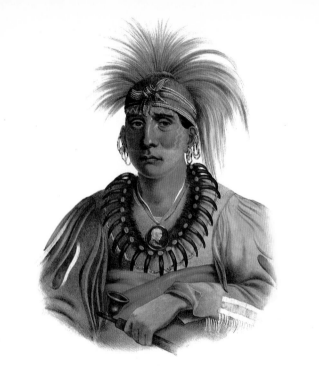

NO-WAY-KE-SUG-GA

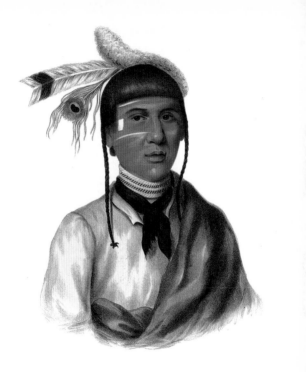

NO-TIN.
A Chippewa Chief

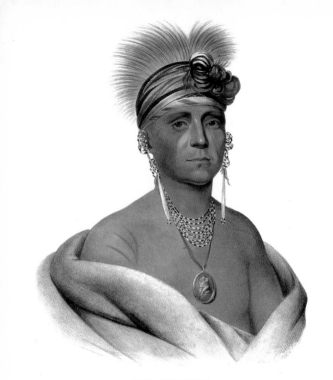

MON-CHONSIA.
A Kansas Chief

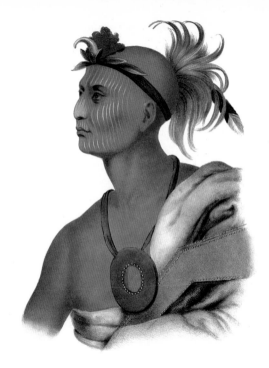

TAH-COL-O-QUOIT

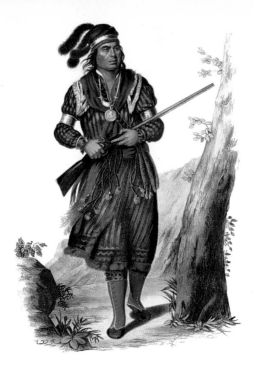

TUKO-SEE-MATHLA.
A Seminole Chief

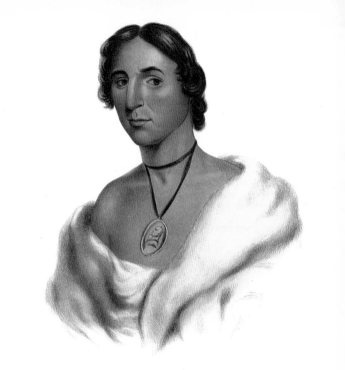

PA-SHE-NINE.

A Chippewa Chief

247

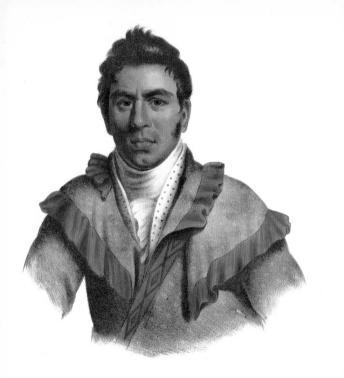

OCHE-FINCECO

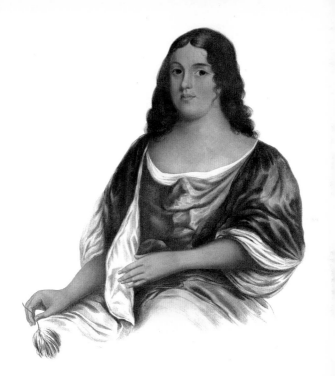

PO-CA-HON-TAS

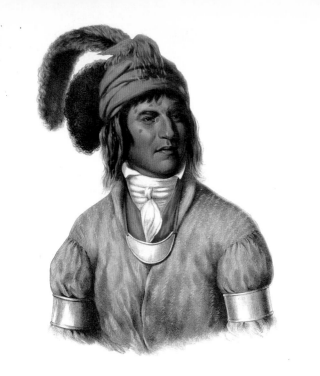

LEDAGIE.
A Creek Chief

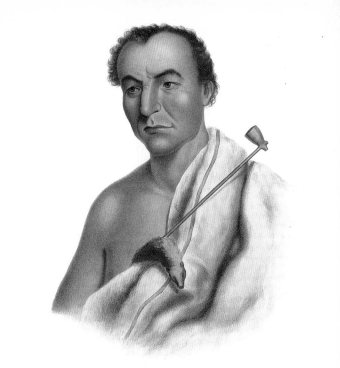

ON-GE-WAE.
A Chippewa Chief

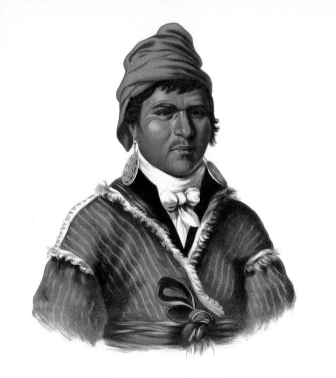

NAH-ET-LUC-HOPIE

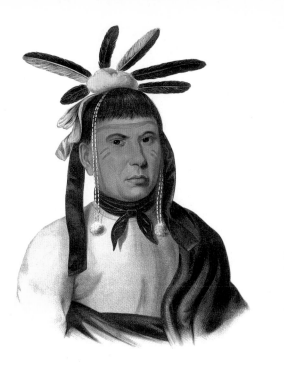

AMISKQUEW.
A Menominie Warrior

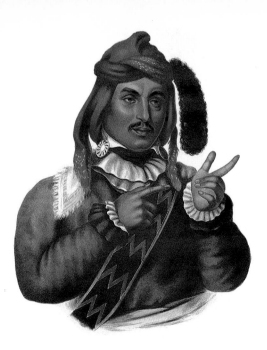

JTCHO-TUSTINNUGGEE

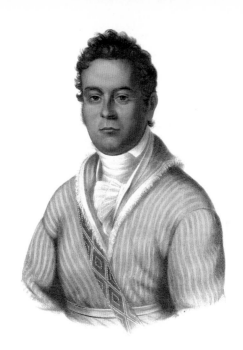

DAVID VANN.
A Cherokee Chief

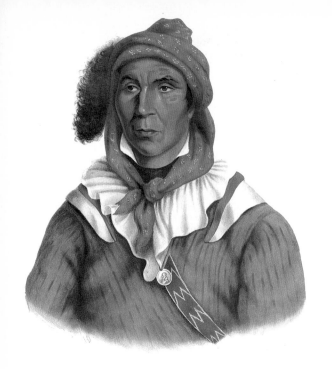

JULCEE-MATHLA.
A Seminole Chief

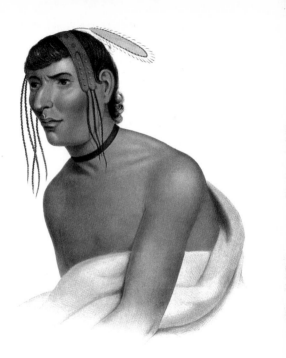

JACK-O-PA.
A Chippewa Chief

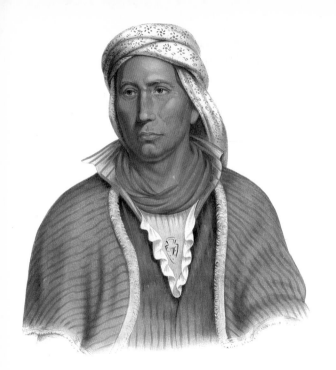

KEE-SHE-WAA.
A Fox Warrior

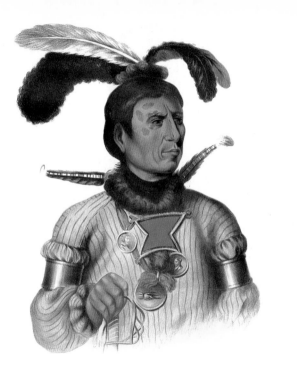

A Winnebago

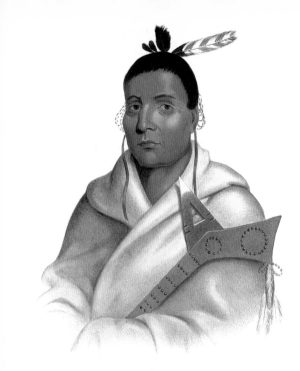

WAA-TOP-E-NOT

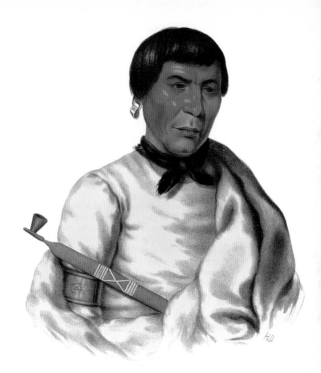

P E E - C H E - K I R.
A Chippewa Chief

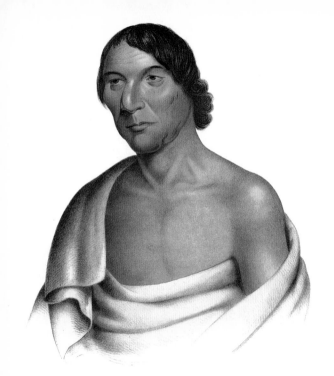

O-HYA-WA-MINCE-KEE.

A Chippewa Chief

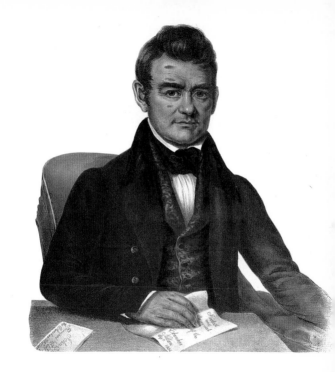

JOHN ROSS.
A Cherokee Chief

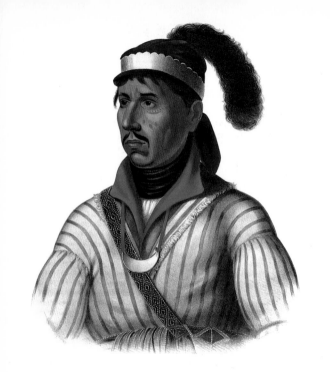

APAULY-TUSTENNUGGEE

CATLIN

BODMER

McKenney and Hall